CUT IT, PASTE IT, SEW IT

A MIXED-MEDIA COLLAGE SOURCEBOOK

QUARRY

Copyright © 2009 BNN, Inc. Originally
Japanese edition published by BNN, Inc.

First published in the USA by
Quarry Books, a member of
Quayside Publishing Group
100 Cummings Center
Suite 406-L
Beverly, Massachusetts 01915-6101
Telephone: (978) 282-9590
Fax: (978) 283-2742
www.quarrybooks.com
Visit www.Craftside.Typepad.com for a behind-the-scenes peek at our crafty world!

ISBN-13: 978-1-59253-643-6
ISBN-10: 1-59253-643-3

10 9 8 7 6 5 4 3 2 1

The original Japanese edition:
Book Cover Artwork: Kayo Yamamoto (LUSiKKA design)
Art Direction and Design: Masanari Nakayama (2m09cmGRAPHICS, Inc.)
Photography: Seiji Mizuno
Editing: Chisa Itou

Printed in China

CUT IT, PASTE IT, SEW IT

A MIXED-MEDIA COLLAGE SOURCEBOOK

BEVERLY MASSACHUSETTS

QUARRY BOOKS

· CHISA ITOU ·

Take
familiar material
and

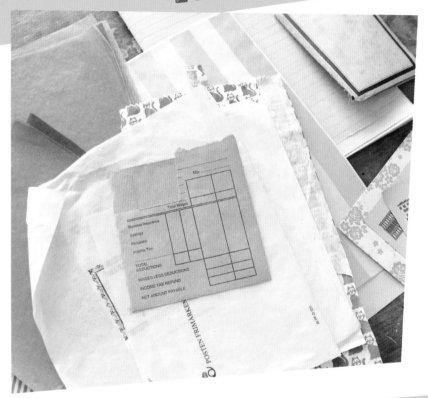

Cut it

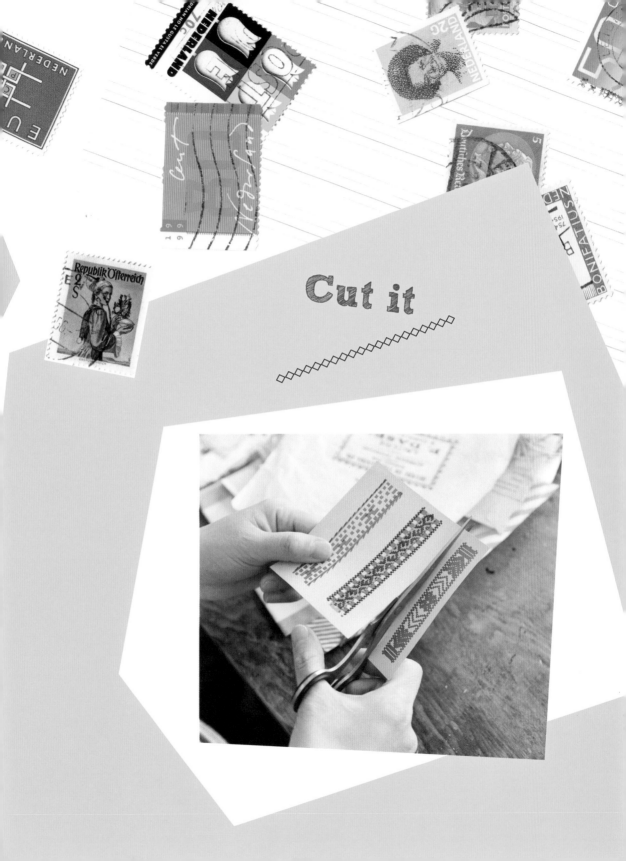

E K

Paste it

EBE
eischütz

ETE

zert
NER
ie III 8°

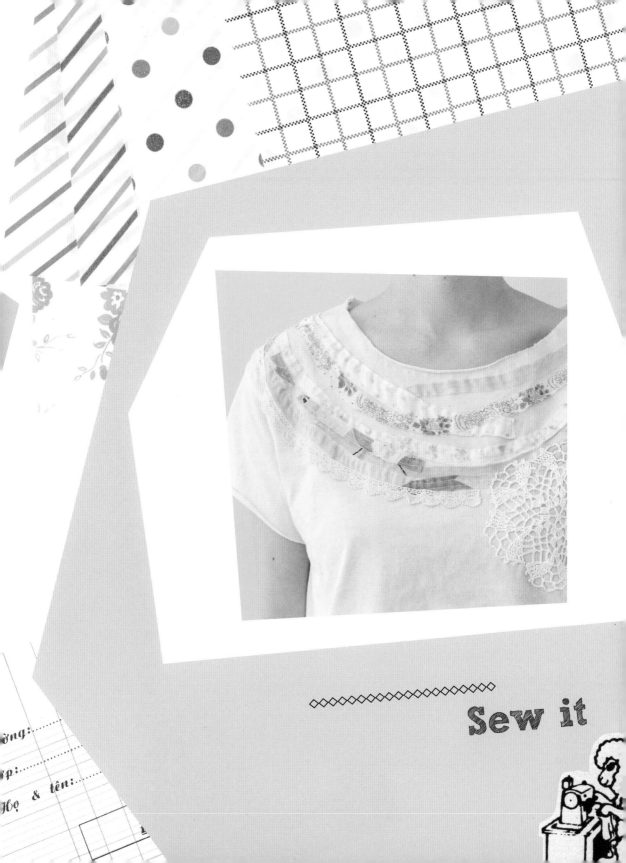

Sew it

Collage is fun!

To make a collage, you don't need
 any predetermined rules.
You don't need complex technologies.
Just follow your instincts, be true to
 yourself, and have fun!

The paper you collect, the scraps
 you just could not throw away,
 the photographs that bring back
 so many memories, are reborn as
 new materials.

*Be careful not to violate copyrights when you
 choose the materials you will use in your collage.

Contents

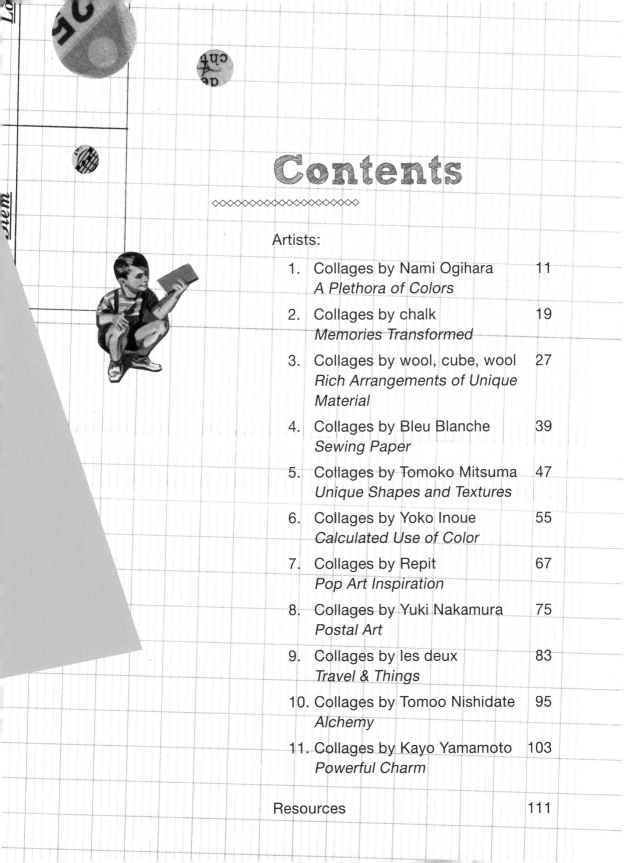

Artists:

Họ & tên:................................

Môn:...................... Thời gian............

Điểm	Lời phê của giáo viên

1 Collages by Nami Ogihara

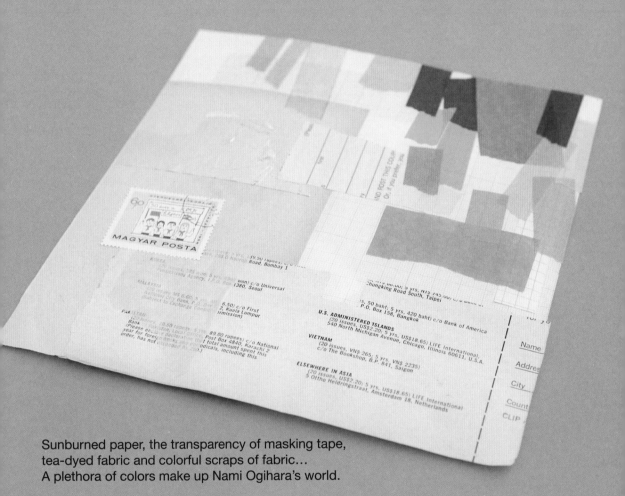

Sunburned paper, the transparency of masking tape,
tea-dyed fabric and colorful scraps of fabric…
A plethora of colors make up Nami Ogihara's world.

A paper collage
Foreign stamps, masking tape, sunburned paper,
colored paper, Vietnamese graph paper

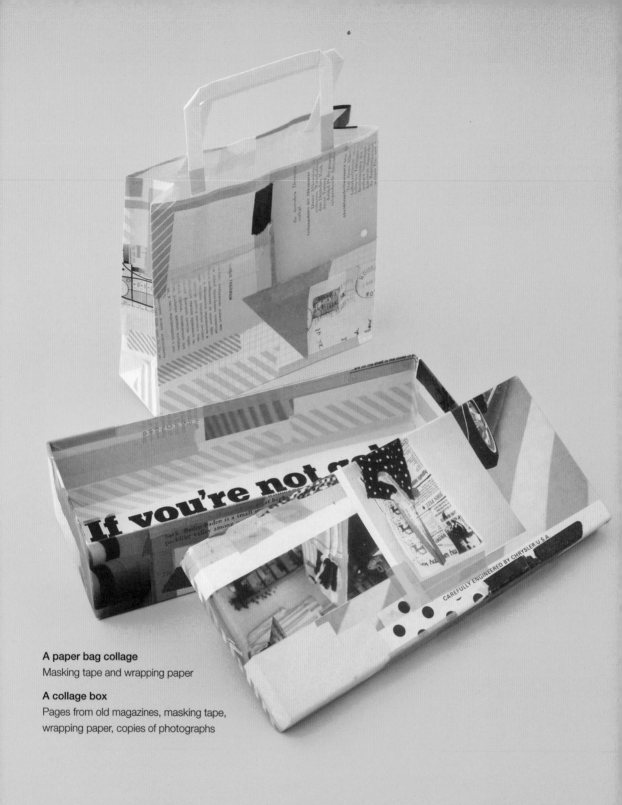

A paper bag collage
Masking tape and wrapping paper

A collage box
Pages from old magazines, masking tape,
wrapping paper, copies of photographs

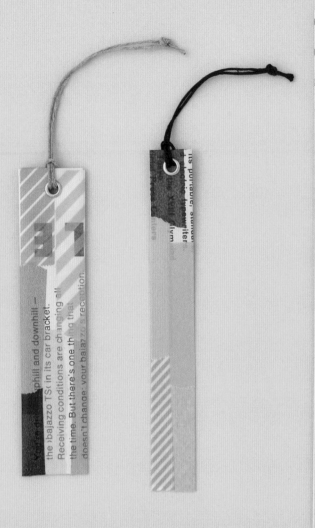

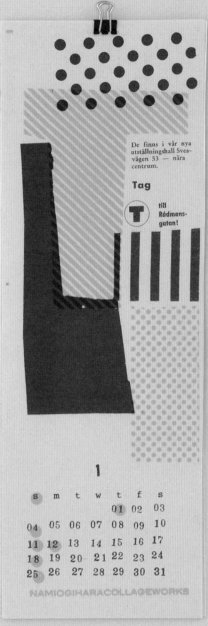

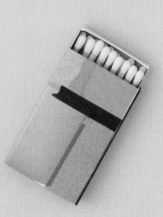

Bookmarks
Heavy paper, grommets, hemp string, pages from old magazines, masking tape

2-color printed calendar
Course paper, 2-color print

Collage matchbox
Masking tape, sunburned paper, matches

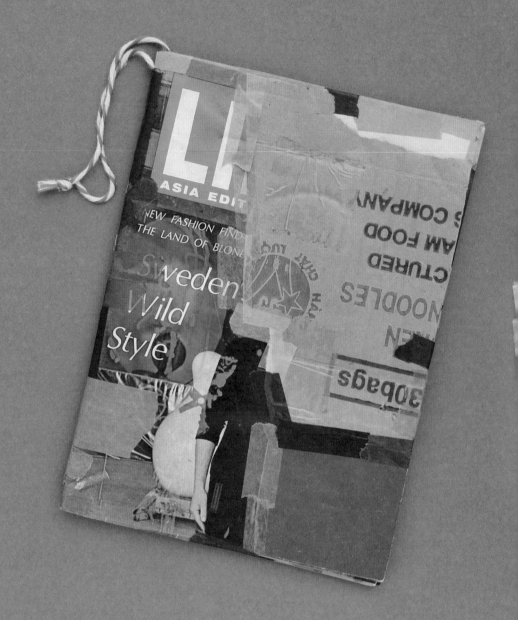

Western magazine collages
Old western journals, masking tape

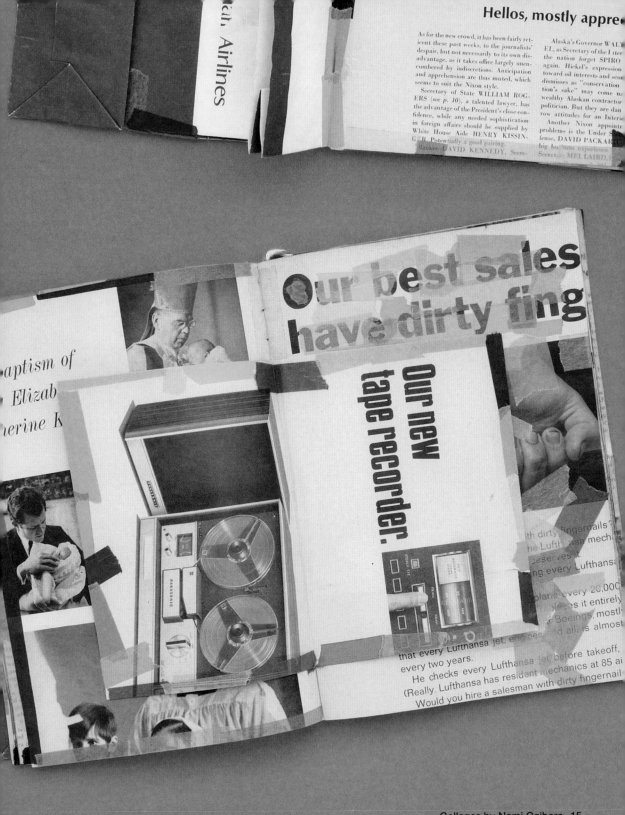

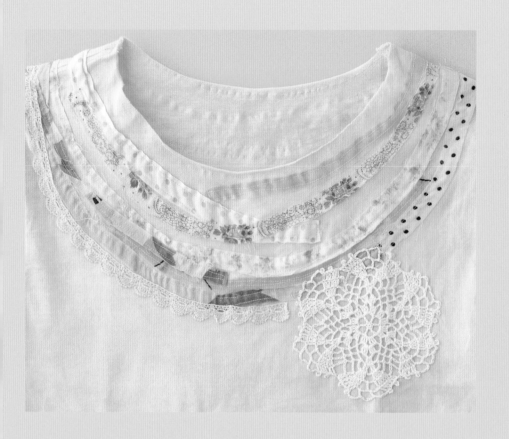

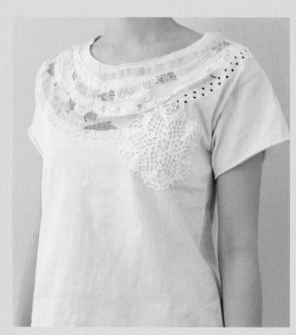

A tea-dyed collage T-shirt
A commercial T-shirt, a hand-crocheted doily,
lace, thinly cut strips of scrap fabric

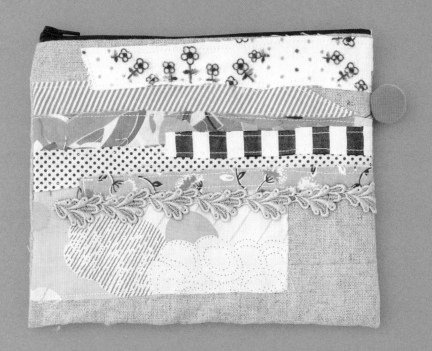

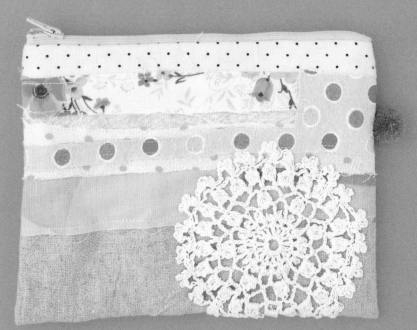

Collage pouches
Hemp fabric, scrap fabric, lace, hand-crocheted
doilies, pom-poms

Artist Interview: Nami Ogihara

⟩⟩ What materials do you use most often? And can you give us some pointers on material selection?

I often use materials such as old journals (*LIFE* or other magazines from the '70s), coarse paper, foreign food packages, or old printed material. For paper, I prefer to use material with sunburned hues or paper that is rough to the touch. For printed material, I often look for prints where the colors are askew, or materials that have logos, illustrations, or other graphics that have a "pop" feel to them. Since I consider all encounters precious, I will often bring back cardboard or milk cartons I've found on a trip somewhere. Fabrics I buy at your run-of-the-mill fabric shop or maybe I will pick up dead stock items, or use material I found on a trip to places like Vietnam, Thailand, Russia, or Taiwan.

⟩⟩ What's your secret to making a good collage?

The collages I make may be simple or colorful, depending on my state of mind at the time, but the trick is to stop at the "moment" when I sense the collage is perfect. In the case of cards, bookmarks, or other miscellany, I start first by covering my base material with my favorite paper, then balance it all out with more elaborate decorations, such as richer colors, logos, or stamps.

⟩⟩ Nami Ogihara

Born in 1974, Nami Ogihara began making and selling postcards, after graduating from junior college. In 2002, she published the booklet *RECIPE*, which is distributed to coffee shops and other venues. She currently works at a chandlery, and continues to create collages out of paper and fabric.

⟩⟩ Contact

URL: http://namiogihara.unber-b.com

2 Collages by CHALK

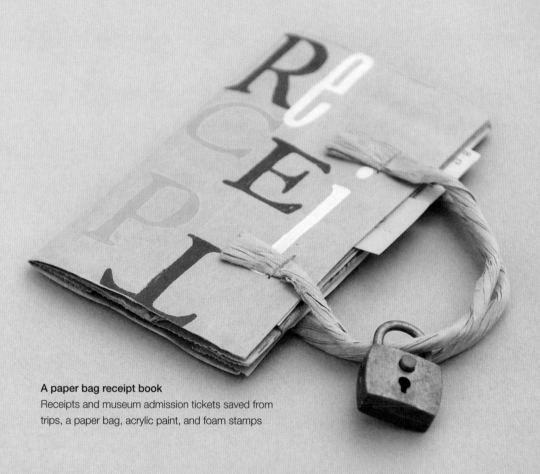

A paper bag receipt book
Receipts and museum admission tickets saved from
trips, a paper bag, acrylic paint, and foam stamps

Gentle collages that are easy to cuddle up to every day.
For CHALK, everyday encounters and memories transform
to become collage material.

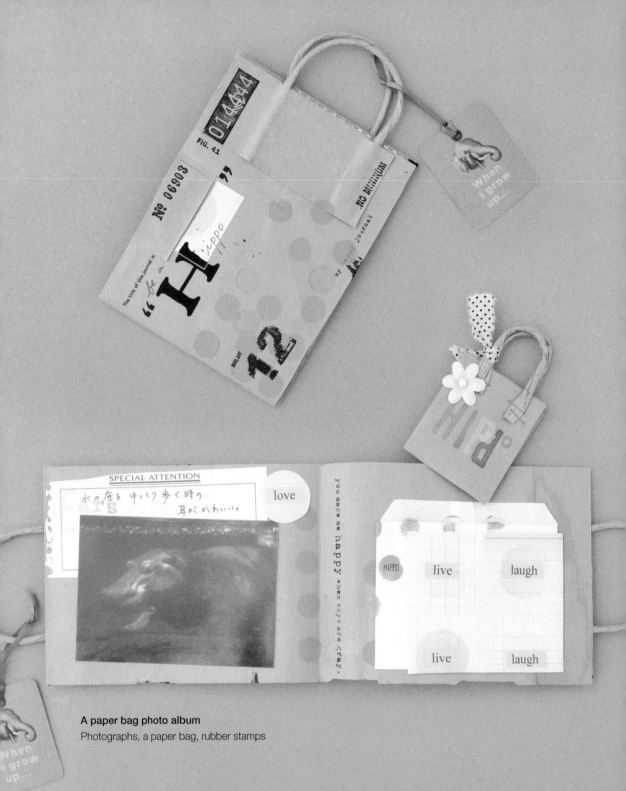

A paper bag photo album
Photographs, a paper bag, rubber stamps

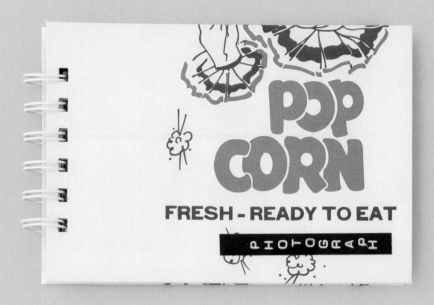

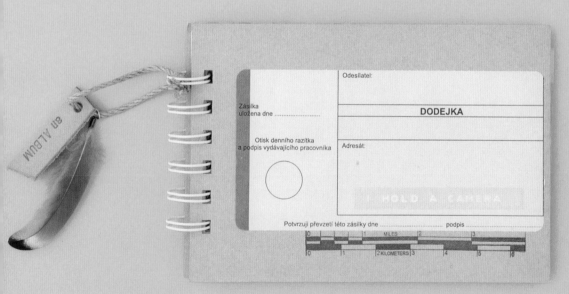

A mini-album

Photographs from trips, a paper popcorn bag,
envelopes from foreign countries, dymo tape, rubber
stamps, feathers, other decorations

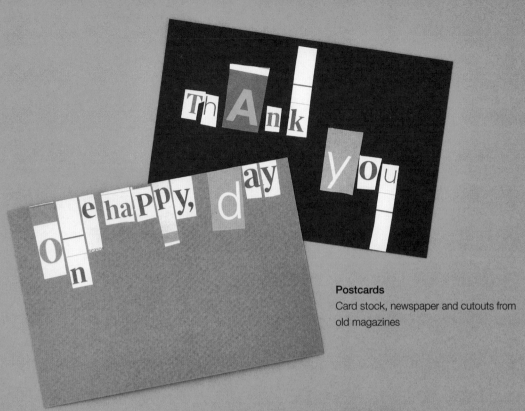

Postcards
Card stock, newspaper and cutouts from
old magazines

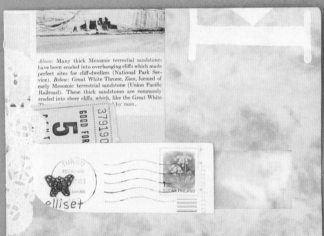

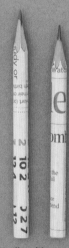

A collage envelope
A window envelope, lace paper, old stamps, cutouts from
old magazines, tickets, a butterfly for accent, acrylic paint,
foam stamp stamps

Pencils with a nostalgic feel
Half-used pencils,
newspaper cutouts

《 An alphabet collage
Card stock, leftovers from a scrapbooking project, old stamps

Altered book
A cardboard picture book, pattern paper, tape, letters
of the alphabet, rubber stamps, sandpaper

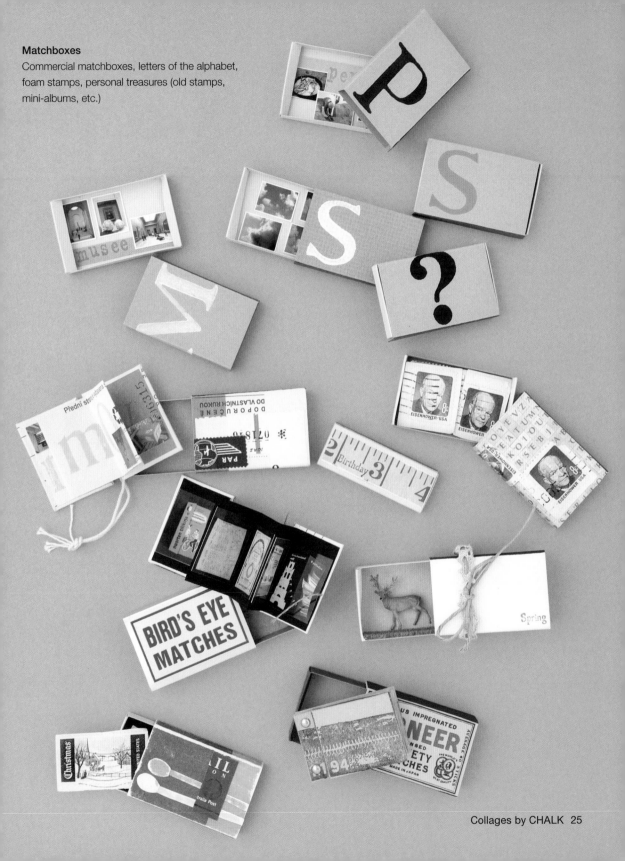

Matchboxes

Commercial matchboxes, letters of the alphabet, foam stamps, personal treasures (old stamps, mini-albums, etc.)

Artist Interview: CHALK

》 What materials do you use most often? And can you give us some pointers on material selection?

I am really drawn to scraps of paper left over from other projects. I use things with a feel and texture that's unique, or that are interestingly colored or shaped; things that contain numbers or letters. Letters and the characters of other foreign languages are particularly interesting for the pure enjoyment their shapes bring, even more so than the enjoyment I get from knowing their individual meanings. For this reason, I think they are particularly suited to collage-making. Then there are things that I feel an odd affinity to, especially pieces of paper that I find when I travel; sometime they will look so much like precious treasures that I don't know what to do with myself.

》 What's your secret to making a good collage?

It makes no difference if you are unable to draw, or whether you are clumsy or dexterous. Even for me, there is nothing more enjoyable than a collage. I derive a small but divine pleasure that exceeds my own imagination from the process of taking apart something that is complete and rearranging its components to use as I see fit. For me, the collage is not so much about the art or forms of expression; it is something that is intimately connected to my everyday life. Like making lunch for yourself out of the leftovers from your fridge, it is a very personal experience, like one's everyday clothes. That's why I am often surprised, even embarrassed, when people find my work appealing. I don't think about trying to combine pretty colors or making a beautiful finished product, I play songs that I like and pick up the scraps of material in front of me, combining and observing them, observing them some more then turning them over, and simply being surprised by and enjoying the random results. I would hope that others will also enjoy the process of incorporating small things into their lives and spending the completely personal moments that collage-making brings.

》 chalk

Author of *ScrapBooking*. Co-author of *Memorable Collage Scrapbooking My Personal Album, The Joy of Scrapbooking,* and numerous other works.

》 Contact

Email: scrapbookingair@hotmail.com
URL: http://members.jcom.home.ne.jp/aleko

3 Collages by wool, cube, wool!

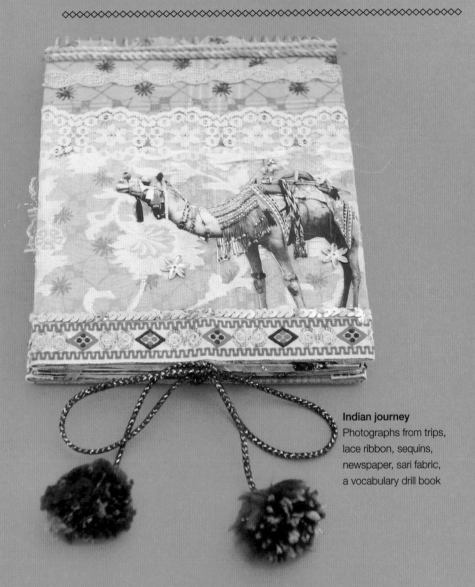

Indian journey
Photographs from trips,
lace ribbon, sequins,
newspaper, sari fabric,
a vocabulary drill book

The collages of wool, cube, wool! are more than distorted expressions of their senses of size, and their rich arrangements of diverse materials are not merely cute creations. They form a unique world unto itself.

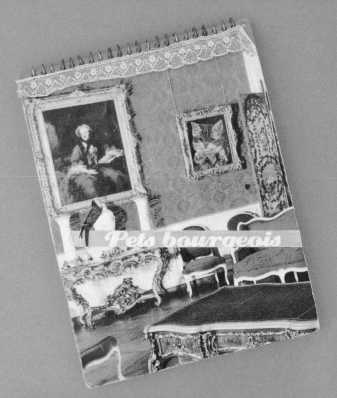

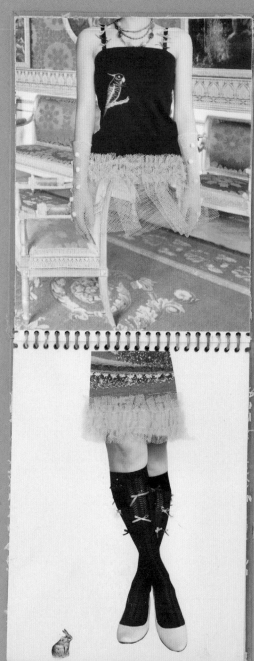

28

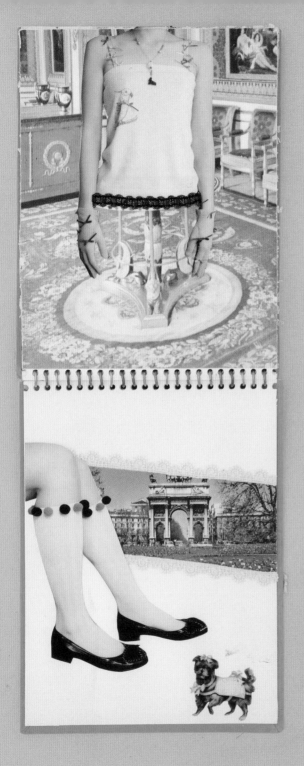
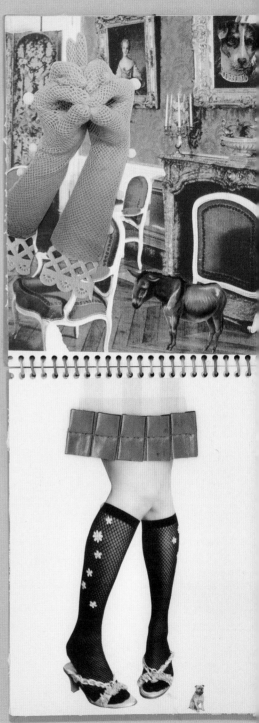

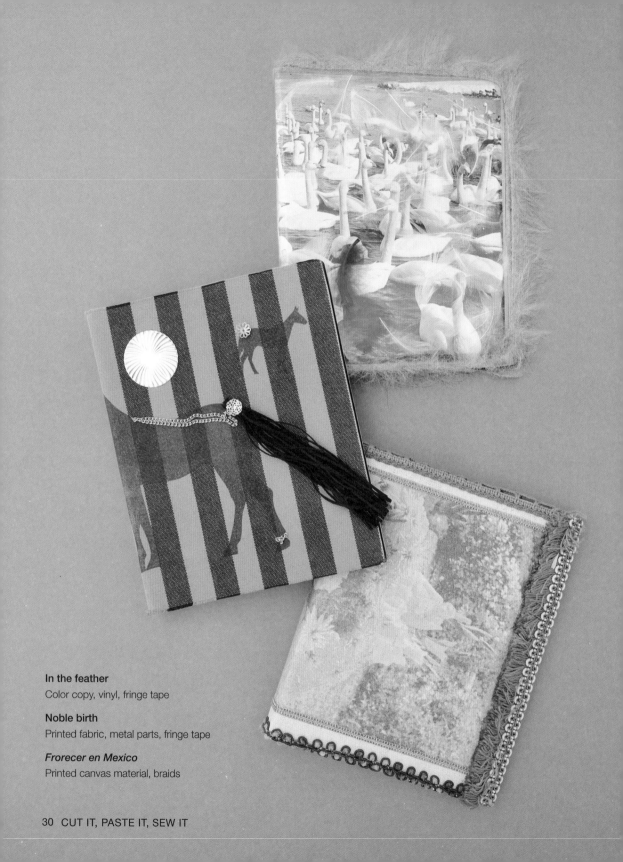

In the feather
Color copy, vinyl, fringe tape

Noble birth
Printed fabric, metal parts, fringe tape

Frorecer en Mexico
Printed canvas material, braids

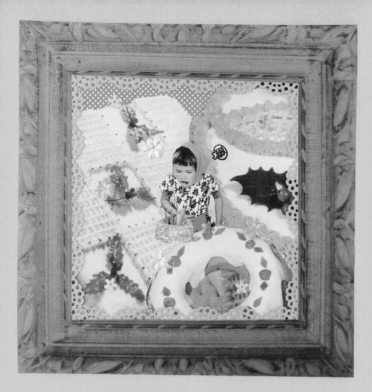

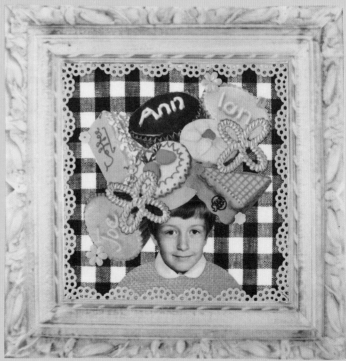

December/March
Photographs, old postcards,
photocopies of real objects, sequins,
metallic parts, lace tape, fabric

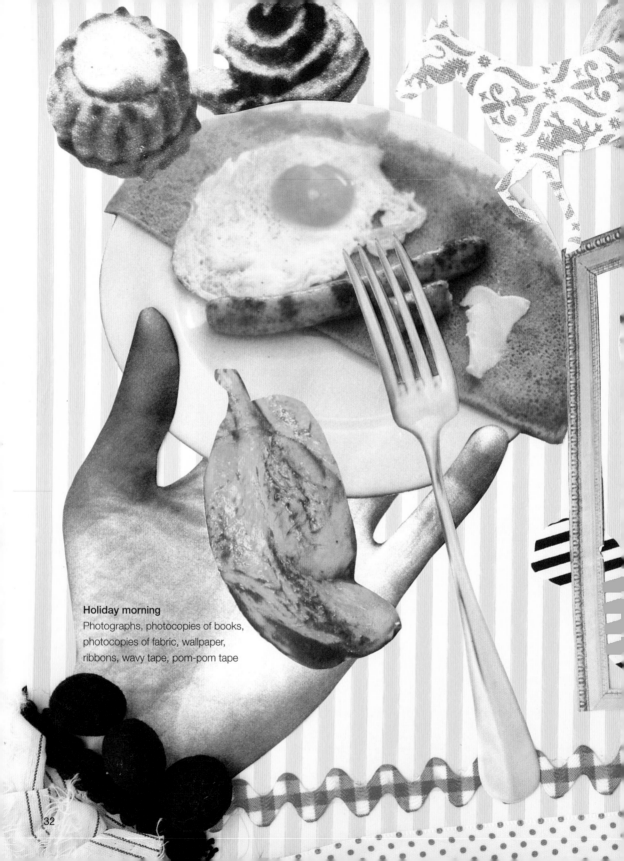

Holiday morning
Photographs, photocopies of books,
photocopies of fabric, wallpaper,
ribbons, wavy tape, pom-pom tape

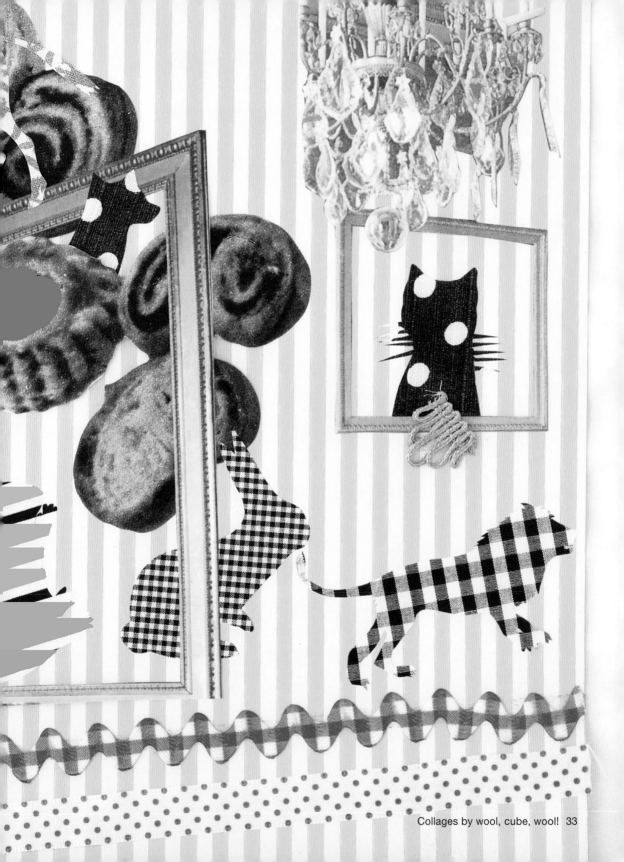

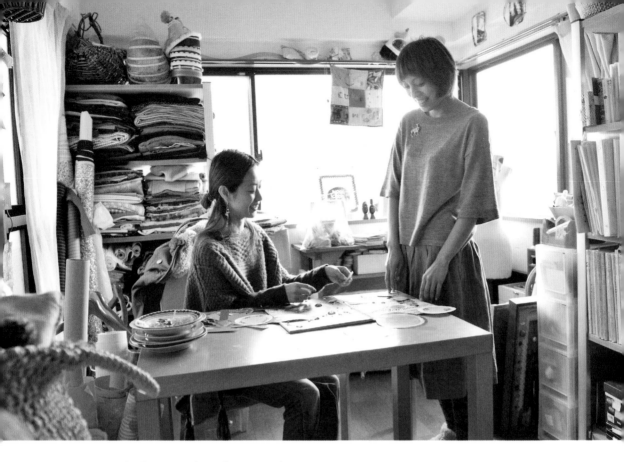

Artist Spotlight: wool, cube, wool!

❯❯ How has wool, cube, wool!, whose business has centered on garment industry-related activities, incorporated collages into its work?

Even though we hold seasonal exhibitions, it's not always easy to articulate the images we want to convey just by showing our work. So in order to get the images across we began to compile collection books for each season. Sort of like taking photographs of our fashion products and adding to them an image. That's how we first began using collages.

❯❯ Your fashion accessories are also created with a fashion-like sense, aren't they?

I suppose so, but it was never really a conscious decision; we were simply enjoying the process of mixing and matching different materials. Looking back, though, we later realized that our creative style is very collagelike.

❯❯ Is there anything you like to pay particular attention to when deciding which combinations of materials to use?

We try to combine items that have different textures. The same is true whether we are working with paper or fabric. With mat material, we combine something that is smooth or shiny because it gives depth to the piece."

❯❯ I found your concept of using photocopies of plates and other objects that we use everyday to render planar expression for use as material in your collages really refreshing.

We once did an exhibition where the theme was "the image of a girlish room." As part of the exhibit we made chandeliers out of paper, but the catalyst for the idea came from our deciding that we wanted to use antique plates as the decorative base for the accessories. We wanted to use antique plates, but realizing that we would never be able to collect so many, we decided just to make photocopies of them. We though it was a great

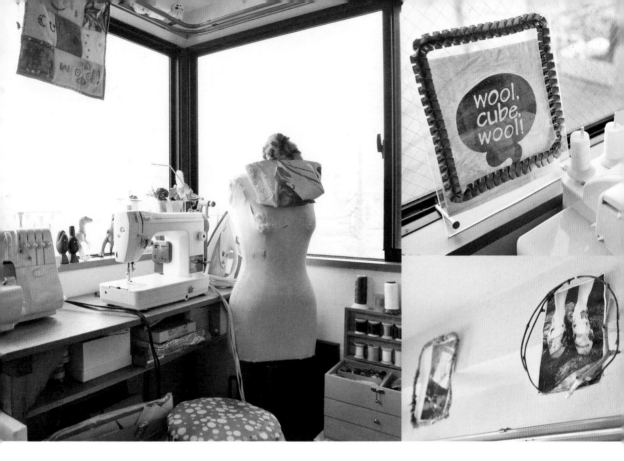

idea because with copies you can enlarge or shrink the images or make them in a variety of different sizes. But when we actually started photocopying, we found that the copies would often be minutely distorted. And though it was completely by accident, we realized that the effect that the distortion added was really quite interesting. I thing we get a much greater stereoscopic effect than with photographs.

》 The ambience inherent in the perspective your work seems to have on the world is truly unique, but what is the source of your inspiration?

I don't think there is any single, tangible thing that we could point to as the thing that influences us, but when we travel together, sometimes it's the scenery, while at other times it's a particular object, but we often find ourselves saying "I can't believe that something like this exists!"; perhaps it's this excitement and emotion that influences our work. Sometimes we will come across an old woman walking through town whose appearance and choices of color and patterns are so outrageous

you want to say "What in the world is that!", but it's just this kind of coordination that we are, in fact, drawn to. It is not just the cool things we encounter in our everyday lives; I think that all of the things that are casually called to our attention accumulate inside of us and eventually affect our expression. Things like old magazines, books and graphics can also be interesting and provide us with hints for expression.

》 You say that you often travel overseas to purchase materials; is there any particular country, etc. that you would recommend?

The Baltic States, which we visited recently, were good. We were in Estonia and Latvia, two really rustic countries. There is a rich handicraft culture there, so there were numerous handicrafts to choose from, and the landscape itself is not completely modernized, so a lot of the historical buildings still remain from the old city. Our work is influenced by the colors of buildings or people, and the color combinations intrinsic to different countries. We find it really interesting that the colors that people

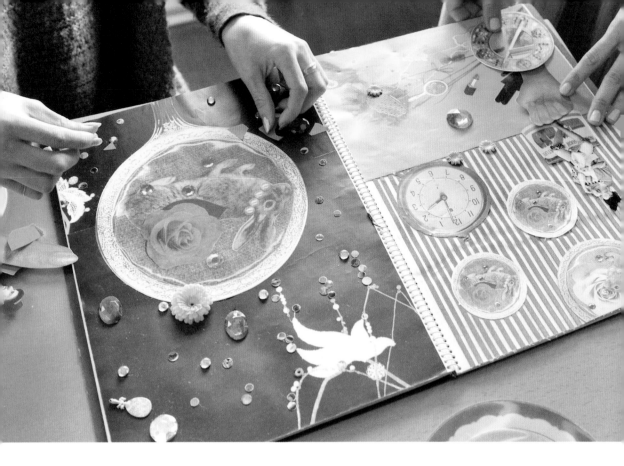

register can vary so greatly from country to country. We are also drawn to the characters of the alphabet as forms of graphic expression. Letters that we can't read become designs in and of themselves. We also make a point of bringing home tickets and maps.

❱❱ What perspectives or standards do you apply when searching for materials?

We always try to have a good stock of materials on hand. We try to pick up things that we find attractive at the moment even if we have no particular use for it just then, because somewhere down the line they will become useful. I think that in terms of variation, we probably have a much more diverse collection of materials than most people.

❱❱ Do you usually go shopping for materials together?

Sometimes we shop together, and at other times, if one of us finds something that we think we can use in our

work when we are not together, we take a photo with the camera in our cell phones and ask the other what she thinks before actually making the purchase.

❱❱ Do you share the same world view?

It's been eleven years since we began working together, so I think that each of us understands what the other is trying to express, and we both understand the other person's way of looking at the world

❱❱ For wool, cube, wool!, what is the allure of the collage?

I think it's the ability to create impossible worlds. The same goes for one's sense of size; being able to create a world of sizes that would not be possible in a given space is what attracts us to the world of collage.

The elements that comprise the collages made by wool, cube, wool!

Postcards

Postcards acquired at foreign flea markets. A trip to the local flea markets is always a must. Every postcard offers a fresh design that incorporates the unique colors and motifs of the country from which they originate.

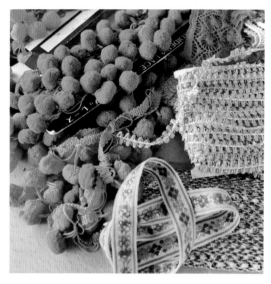

Ribbon and tirolean tape

Ribbons are also used to make fashion accessories. Their collection contains a diverse array of material whose vivid colors and patterns capture the eye.

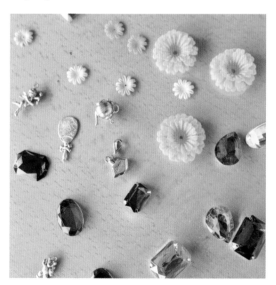

Beads and other diverse items

These items are not always used as is; photocopies made in a variety of different proportions are used to accentuate their work.

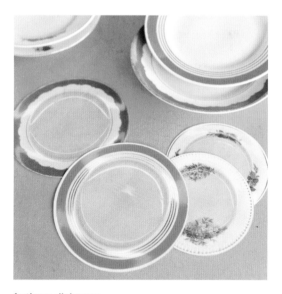

Antique dishware

Plates of charming colors and patterns are also copied and used as collage material. The ever changing distortions of light give birth to diverse expression.

Artist Interview: wool, cube, wool!

❱❱ What materials do you use most often? And can you give us some pointers on material selection?

We often use antique books, picture postcards, photographs, as well as lace and fabric, and sequins, beads, and a diverse array of other clothing ornaments. Sometimes we use them as is, and sometimes we change their proportions by making photocopies. Clothing ornaments are interesting because they lend a sense of texture that isn't possible with paper alone.

❱❱ What's your secret to making a good collage?

We make sure that we have a theme and a general concept for presentation before collecting and combining materials. We make copies of the same thing and lay them side-by-side, or increase or reduce their proportions in relation to their actual sizes to create unique worlds.

❱❱ Where do you go most often to purchase materials?

We do not have a particular place or places where we shop, but whenever we travel overseas, we make a point of visiting the local stationery stores, antique book shops, and handicraft stores. We buy and bring back anything we find particularly interesting.

❱❱ wool, cube, wool!

wool, cube, wool! Is a brand unit specializing in the design and manufacture of bags, accessories, and other fashion accoutrements. Integrating diverse materials to create products that are like collages, this duo's work offers an atmosphere that is uniquely stateless. Their publications include *Collage Sewing*.

❱❱ Contact

Email: wool-cube-wool@u01.gate01.com
URL: http://members.jcom.home.ne.jp/aleko

 # Collages by Bleu Blanche

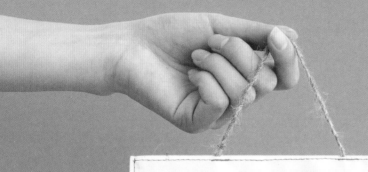

Collage calendars
Copies of photographs,
copies of fabric, the numbers
in the calendar, lace,
masking tape, a wooden spoon,
sweets packages

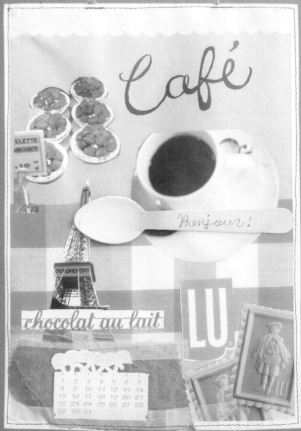

Sewing paper—an innovative concept
Bleu Blanche's collages give new expression to familiar materials.

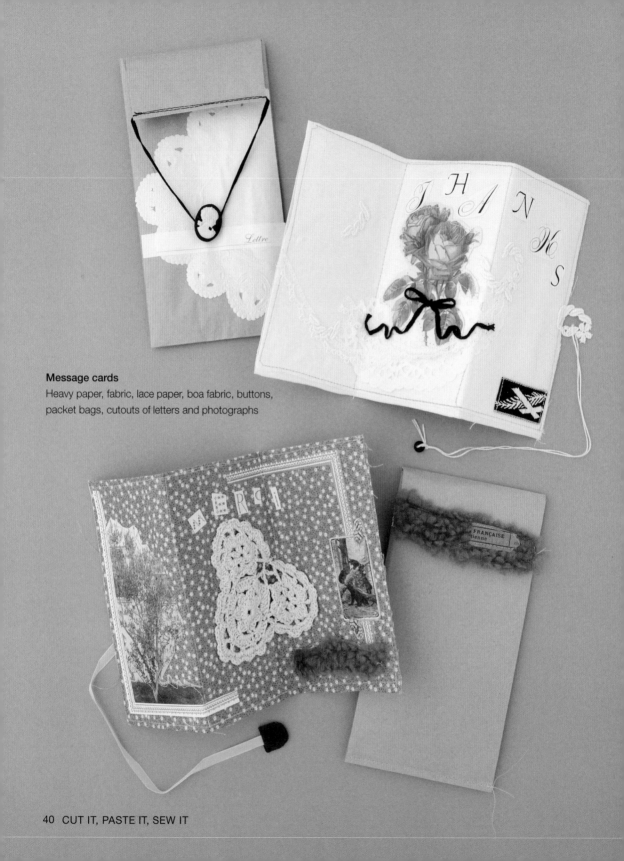

Message cards

Heavy paper, fabric, lace paper, boa fabric, buttons,
packet bags, cutouts of letters and photographs

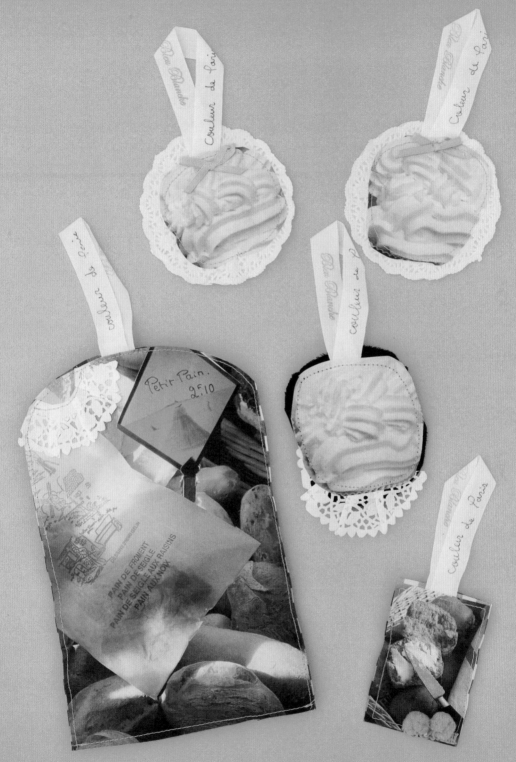

Collage ornaments

Copies of photographs, lace paper, ribbon, fabric

Collage travel notebooks

A favorite notebook, paper items found on
a trip, photographs

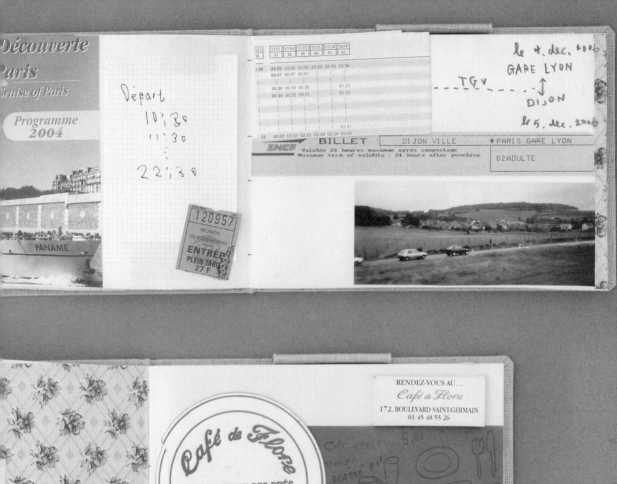

Découverte
Paris
Cruise of Paris

Programme
2004

PANAME

Départ
10:30
11:30
:
22:30

120957
RÉUNION
DES MUSÉES NATIONAUX
ENTRÉE
PLEIN TARIF
27 F

le 4. dec. 2006
GARE LYON
TGV
DIJON
le 5. dec. 2006

BILLET
SNCF
DIJON VILLE → PARIS GARE LYON
Valable 24 heures maximum apres compostage
Maximum term of validity : 24 hours after punching.
02ADULTE

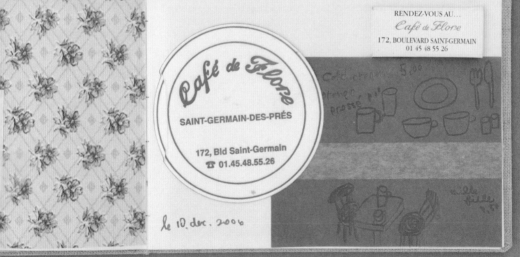

RENDEZ-VOUS AU...
Café de Flore
172, BOULEVARD SAINT-GERMAIN
01 45 48 55 26

Café de Flore
SAINT-GERMAIN-DES-PRÉS
172, Bld Saint-Germain
☎ 01.45.48.55.26

le 10. dec. 2006

LES FRA... ...PAIN
LE...

BOULANGERIE

Desserts

...issants

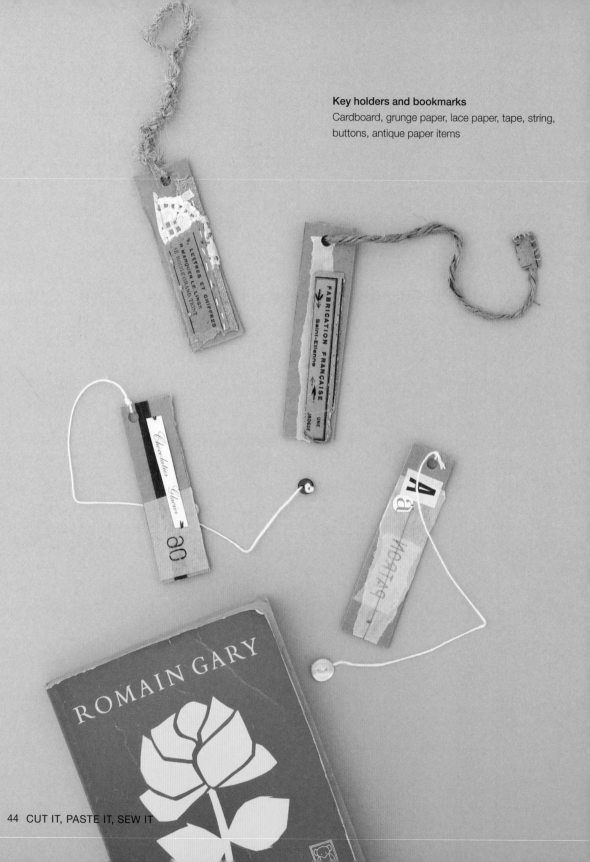

Key holders and bookmarks
Cardboard, grunge paper, lace paper, tape, string,
buttons, antique paper items

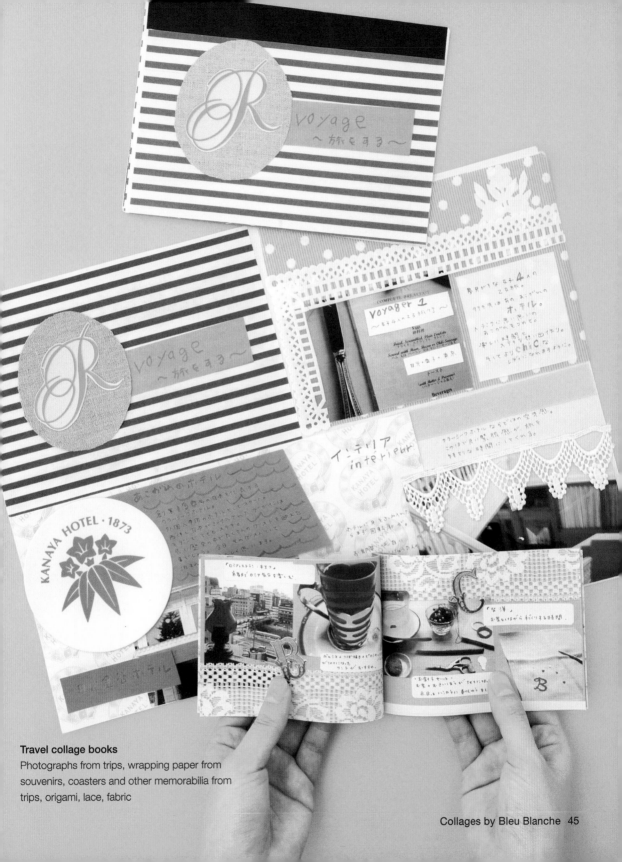

Travel collage books

Photographs from trips, wrapping paper from
souvenirs, coasters and other memorabilia from
trips, origami, lace, fabric

Artist Interview: Bleu Blanche

❱❱ What materials do you use most often? And can you give us some pointers on material selection?

For the base of the collage we use cardboard or thick paper or some other simple material, and to provide accents we use fabric, lace, buttons, and English newspapers. We also use western books, and movie flyers, photographs we've taken ourselves or copies of photographs. For the main focus of a collage, we choose items that suit our individual aesthetic senses and expand upon the image. Sometimes we use the packaging from sweets or fashionable items as reference, and sometimes we actually incorporate the packages themselves; you can simply cut out and use the words, for example, so they offer a variety of uses and applications.

❱❱ What's your secret to making a good collage?

A lot of the time we decide on a theme first. To the memories and souvenirs from our trips we add photographs and wrapping paper, ornaments and decorations, and make them into travel books, and such. The secret is not to try to achieve too much; we limit our materials to a main item plus lace plus cutouts of letters. Adding extra touches, such as hand sewing or machine stitching, also makes a difference. It's also necessary to pay attention to balance—to leave a little breathing room. For us, the secret lies in hand or machine-sewing the paper and cloth material! But even more important is to have fun.

❱❱ Bleu Blanche

Aki + Yumi, a handmade craft-making sister unit, contributes widely to the art in activities based on the concept of "giving form to cute + fun. The duo uses reserved studio space where it holds classes in creating handmade crafts and sells its work and variety goods. Bleu Blanche's publications include *Crafting with Your Favorite Fabrics*, *Hawaii's Charming Designs* and numerous other works.

❱❱ Contact

Email: blueblanche@star.odn.ne.jp
URL: www2.odn.ne.jp/blueblanche

5 Collages by Tomoko Mitsuma

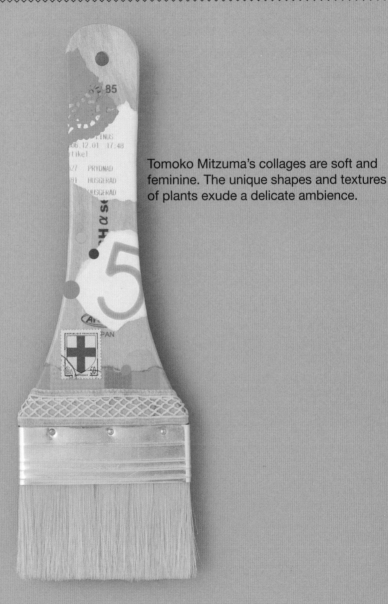

Tomoko Mitzuma's collages are soft and feminine. The unique shapes and textures of plants exude a delicate ambience.

Collage object: Brushes

A brush, lace paper, antique lace, paper items

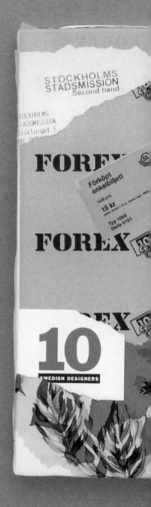

Kyoto/Stockholm/Paris
Canvas, lace paper, leaves, paper items gathered on trips

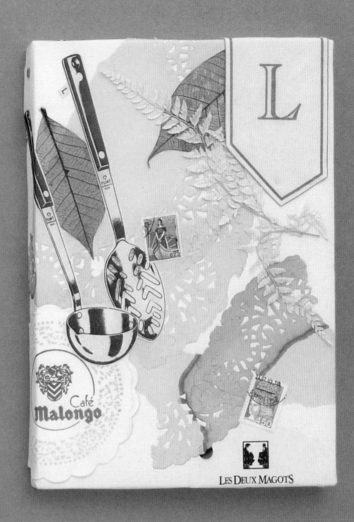

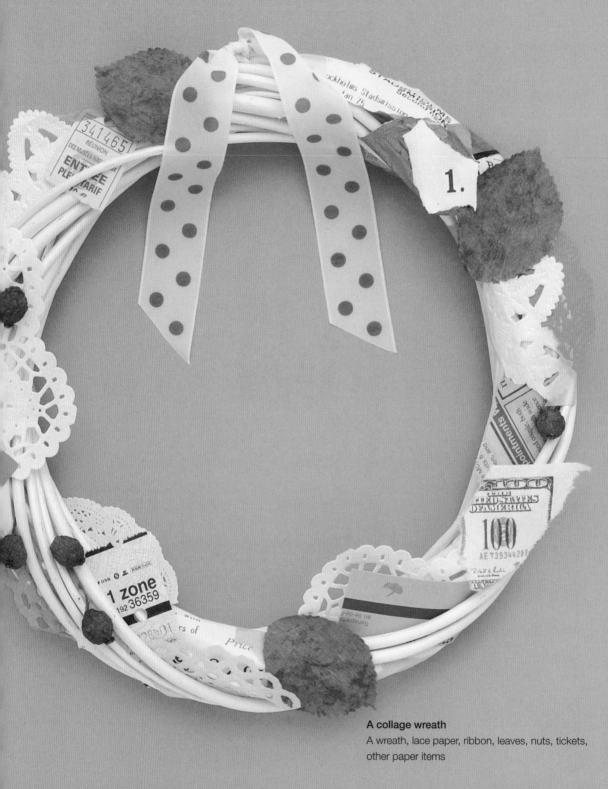

A collage wreath

A wreath, lace paper, ribbon, leaves, nuts, tickets, other paper items

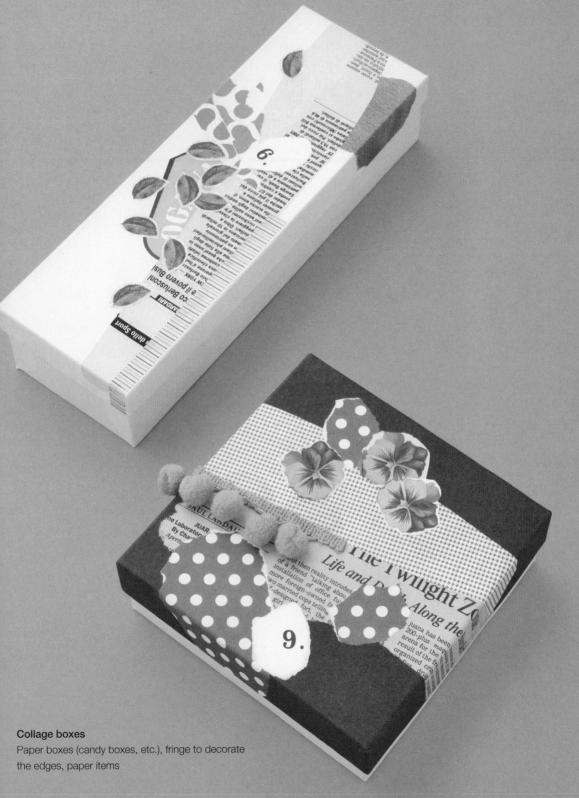

Collage boxes
Paper boxes (candy boxes, etc.), fringe to decorate
the edges, paper items

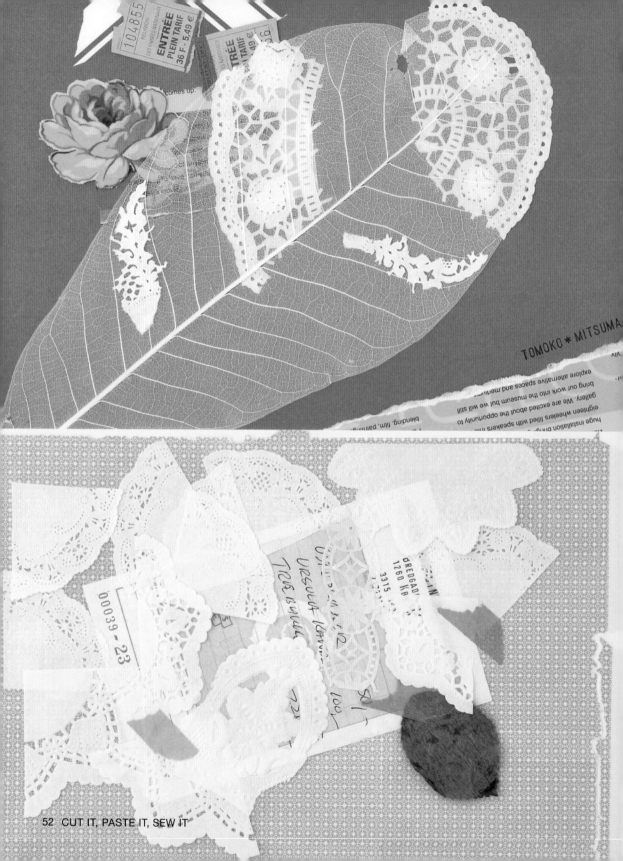

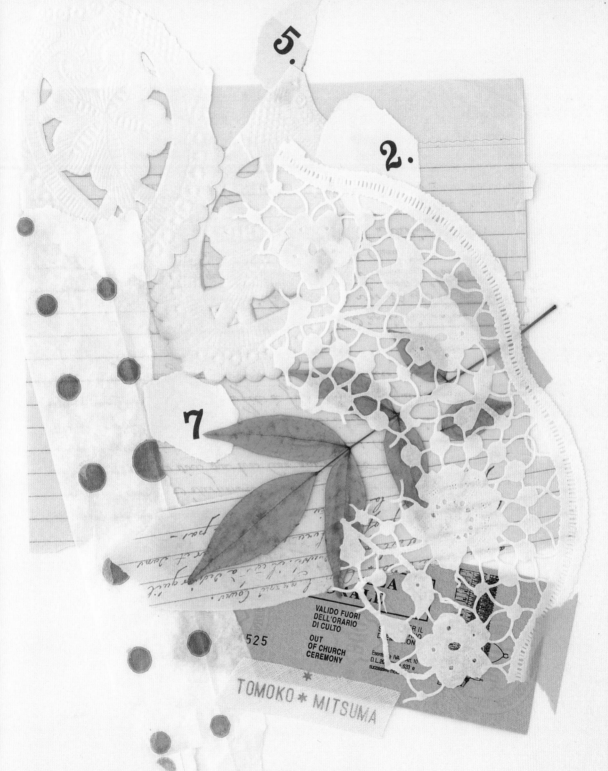

Collage Work Dec. 2008/Collage Work Feb. 2009/Collage Work Jan. 2008

Leaves, lace paper, paper items

Artist Interview: Tomoko Mitsuma

》 What materials do you use most often? And can you give us some pointers on material selection?

I like to use tickets, flyers, shop cards, coasters, receipts, and paper bags from the stores I visited on my trips, cutouts from old magazines, pretty wrapping paper, the back side of the envelopes I receive everyday. Lace paper, dry leaves, fake leaves, and stamps. In short, anything that catches my attention on a daily basis, I keep. I pay particular attention to the textures, patterns, and colors of paper. I also use stamps a lot.

》 What's your secret to making a good collage?

I like to fill my collages with memories from my travels, and combine the textures of plants and paper. Also, making canvas, boxes, or other three-dimensional objects into collages can be a lot of fun, and I think everyone should try it. I think that whenever you find some paper materials you like it's important to be free with them and have fun making them into whatever kind of collages you happen to envision at the time. You shouldn't try to fill every space; creating open spaces as well as highly concentrated spaces – in other words, creating a well-modulated balance—is important.

》 Tomoko Mitsuma

Display designer and artist Tomoko Mitsuma creates objects and collages using plants and holds exhibits incorporating spatial interpretation. In addition to creating display designs for stores, she is also an active member of the display unit "m&m&m's." Writing for "m&m&m's," she has published *The World's Prettiest Paper* and *The World's Prettiest Packages*.

》 Contact

URL: www.mitsumatomoko.com

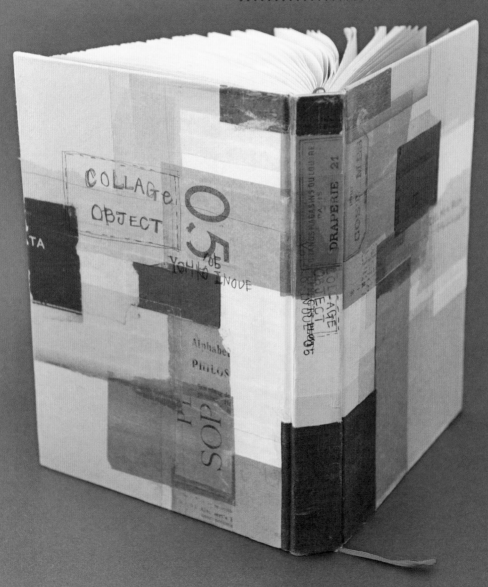

New hues created by superimposing different colors …
The calculated use of colors is what makes Yoko Inoue's
collages so unique.

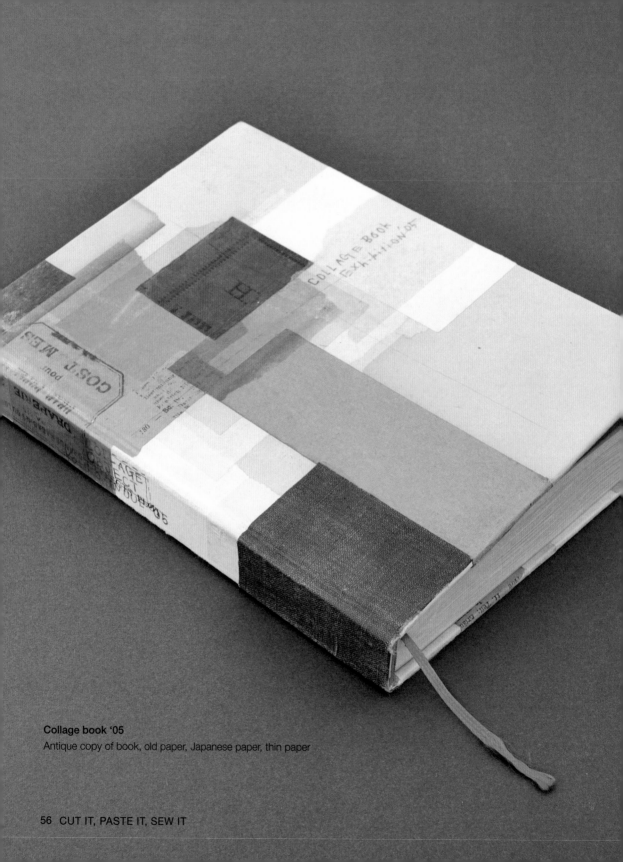

Collage book '05
Antique copy of book, old paper, Japanese paper, thin paper

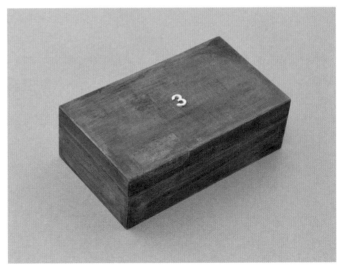

Paulownia box 3

An antique paulownia box, used paper,
acrylic paint, varnish, metallic number cutout

Happy New Year card
Heavy paper, used paper, old newspaper,
old magazines

» Calendars: August, October
Illustration board, used paper, Japanese paper,
coarse paper, computer-generated lettering

DY ELSE'

IRLINE IS PROUD TO FL

EST SOCCER TOURNAME

A HAPPY

NEW

YEAR

PETITE
DE L

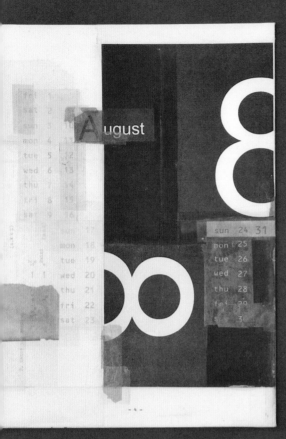

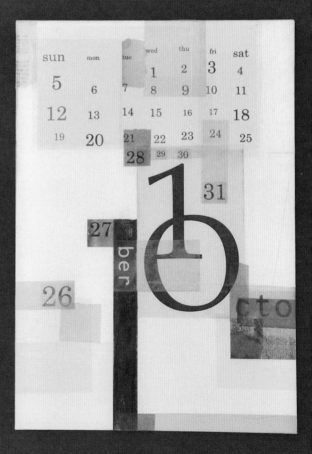

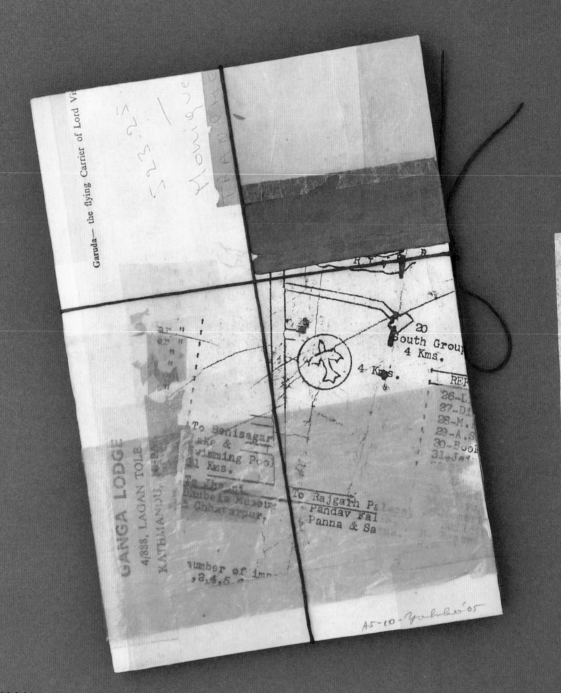

Midnight express notebook

An old notebook, used paper, Japanese paper, old maps

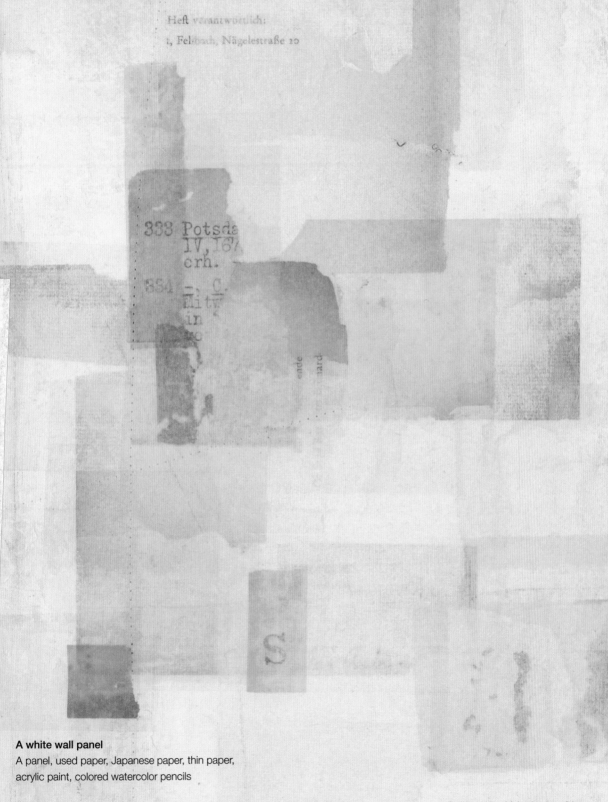

A white wall panel
A panel, used paper, Japanese paper, thin paper,
acrylic paint, colored watercolor pencils

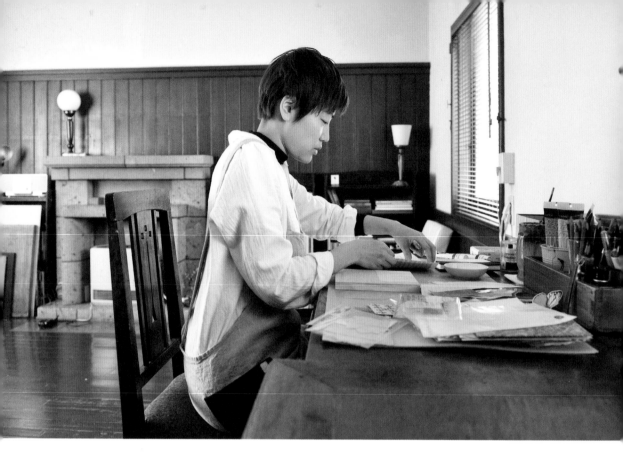

Artist Spotlight: Yoko Inoue

》 What was it that first got you interested in collages?

I started out as an oil painter, but around the time I began to wonder if oil painting was actually the thing for me, I decided just to try pasting paper. I was an avid photographer in college and I thought it may be possible to do something using pictures. I began by pasting a bunch of pictures on canvas or panels, and eventually started pasting paper, too. This is what first inspired me to make collages.

》 How did your current style develop?

I had spent a lot of time looking at other people's work and as I looked I eventually started to say to myself, "I'd like to do this, too, or maybe even I could do something like that, as well." So I started out by imitating the work of others and eventually developed my own style. I was

influenced by a number of artists—I particularly like artists like Kurt Schwitters, Anselm Kiefer and Robert Rauschenberg. As far as oil painting goes, I was also influenced by the work of Kenzo Okada and Nui Sano. Although this is somewhat of a vague statement, "I like paintings that have strong collagelike elements to them.

》 What would you say is the "trick" to creating collages?

I can see why one would like to bring together a variety of different colors, but I think it is important to narrow choices to the colors you particularly like. But one needs to be careful because any given color, such as red, for example, will have different intensities—some may be highly intense, while others may not be very intense at all. The same goes for brightness—there are extremely bright reds and well as very dark reds. Within this range of choices, it is important to be aware of your own preferences for brightness and intensity, and to choose and collect colors along those lines. Otherwise, you run the risk of creating collages that lack uniformity. I am

often asked if I create my collages solely on my sense of aesthetics, but it is much more than that. A lot of careful calculation goes into it as well. I always think carefully about balance, which intensities of blue, for example will harmonize best with which intensities of red. If you develop an awareness for such things, eventually you will be able to tell at a glance how balanced a piece will end up being. If you bring the wrong colors together, you will end up with something that looks rather grouty, so the balance between adjoining colors and the overall uniformity of the collage is really important. I think that adding accents of vivid color is good, but only if the addition is calculated with consideration of the overall uniformity of the color scheme. But the first and most important step is to learn what tinctures and combinations of color appeal most to you.

❱❱ Do you use any materials other than paper?

"Sometimes I use fabric or wire. I might even use dry flowers for accent. There are a number of nonpaper items that I use."

❱❱ From your work and looking around your studio, I get the impression that you are partial to slightly aged things, things that have a certain charm.

"I am drawn to sunburned paper or rust, things that the passing of time has caused a natural transformation in form or color. But it is not that I am seeking some sort of nostalgia; its just that I really like such textures in the materials I use. I like them in the same way that I would say "I like apples." There is no concrete reason, I am just drawn to them."

❱❱ I believe you've collaborated with Kurashiki Isho on the "Masking Tape" pieces, and that you also create haberdashery…

I didn't approach Kurashiki Isho with a request to make masking tape. It all started because I wanted stationery and wrapping paper that that used my own collage work. When I sent then a sample of my work, they proposed the idea of masking tape. Up until that point I has liked and often used white commercial tape in my

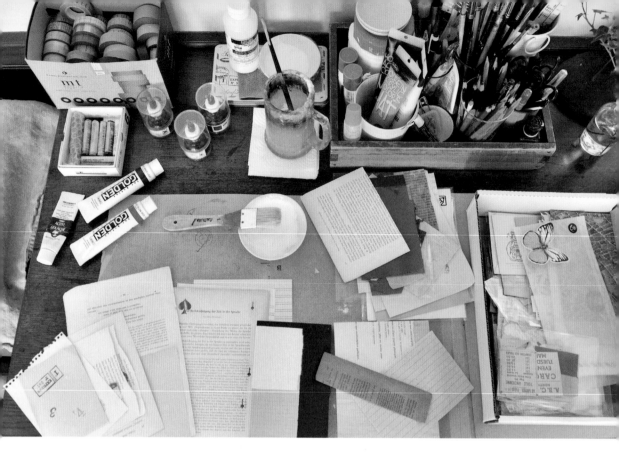

collages, but I had never really used much masking tape before. I came up with the idea of superimposing my creations on masking tape not because I was looking to make something that I could use in my own work, but because I got the impression that there are a lot of people who think that collages are difficult to make. I wanted to create something for people who like to use a variety of goods to "create," to show them how their work could be transformed into something that looks authentic simply by adding a single piece of material.

What is the allure of the collage for Yoko Inoue?

I like the fact that you don't have to be an accomplished artist to create a collage. Collages are highly influenced by the quality of the materials you use. Somehow it all seems to come together; unlike drawing or painting where skill plays a huge part, with collages you can sort of camouflage your own (artistic) weakness. I would have to say that this is what I find most alluring about collages. To create something that is a little sophisticated, all you have to do is past some materials together. This is

why selecting the right materials is so vital. It should be more than deciding to make something out of the things you find at home. One should be willing to paint such materials to transform them into the aesthetic sense that suits him or herself, or to purposely dirty the material… It is important to be willing to process what you have.

Is there any particular piece of work that you think you would like to create in the future?

At the moment, I think I would like to work with ceramics. I would like to use ceramics as material, maybe making a lot of platelike items, like china or tiles, and using them as materials for my collages. In addition to paper, I have also used stones and steel objects in my work. There are a number of things I am interested in, such as ceramics, block prints, and glass… I would like to use them all at some point.

The elements that comprise the collages of Yoko Inoue

Tools for applying color

Acrylic paint and watercolor painting tools, etc. If she cannot find the right colored paper, she paints used paper until she achieves the tints and hues she wants.

Her favorite stamps

The stamps on the left are CRAFT LOG original number stamps. Yoko Inoue purposely dirties them with ash or other materials to give them and aged, well-used feel.

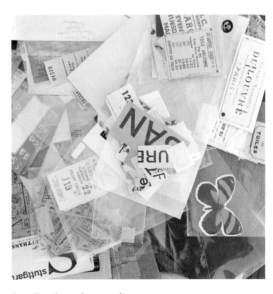

Old western magazines, etc.

In her desk you can find a diverse array of old western journals, music scores, and other kinds of paper material.

A collection of paper items

Tickets, scraps of paper, tags, and diverse other paper items are all neatly sorted.

Artist Interview: Yoko Inoue

》 What materials do you use most often? And can you give us some pointers on material selection?

I use a lot of paper. The point is to be conscious of your preferences in paper and to avoid using too many colors.

》 What's your secret to making a good collage?

I calculate how the piece should be put together to get an idea of the structure. Then I decide whether the overall aspect should be simple or colorful depending on the project.

》 CRAFT Log. Yoko Inoue

Yoko Inoue is a graduate of Kyoto University of Art and Design. She is an instructor and her work as a designer for the covers of magazines, books, etc.has been published as instructional material on making collages on paper surfaces. She also holds regular exhibits and workshops in galleries and other venues, and has launched "CRAFT Log," a collaborative project with haberdashery manufacturers.

》 Contact

URL: www.craft-log.com

7 Collages by Répit

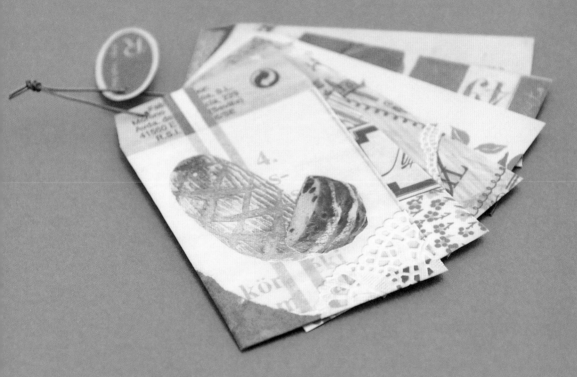

Répit's collages are made with someone in mind, as gifts
to give others. Their pop feel exudes a curious warmth.

A set of small envelopes full of collages
Photographs, ribbon, cutouts from old magazines,
a French game board, old button sheet, lace
paper, stamps

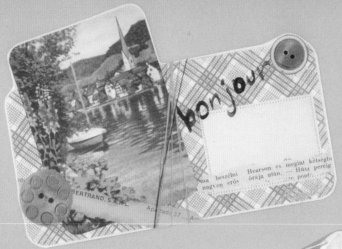

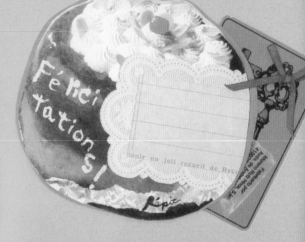

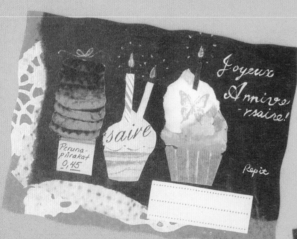

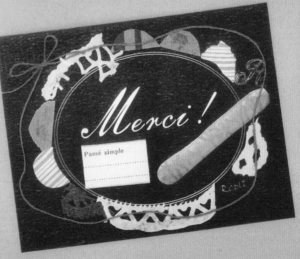

Message collage cards

Old playing cards, magazines, photographs, buttons, lace paper, cake cups, wrapping paper, string

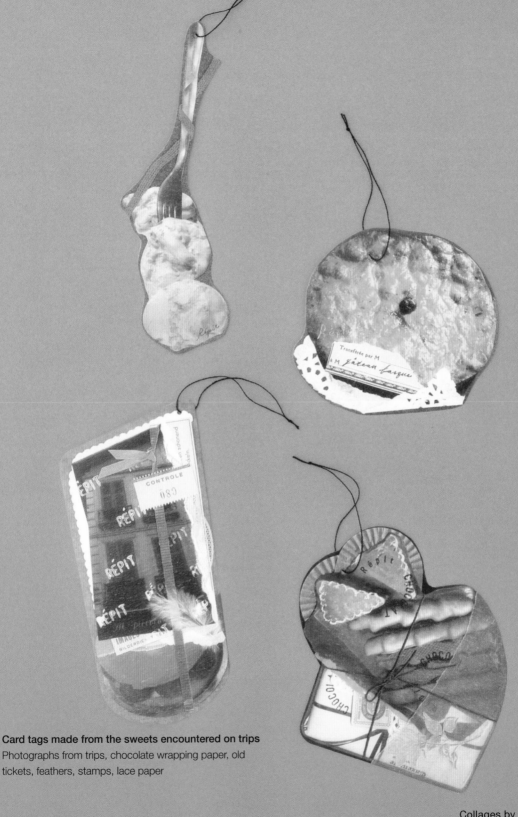

Card tags made from the sweets encountered on trips
Photographs from trips, chocolate wrapping paper, old
tickets, feathers, stamps, lace paper

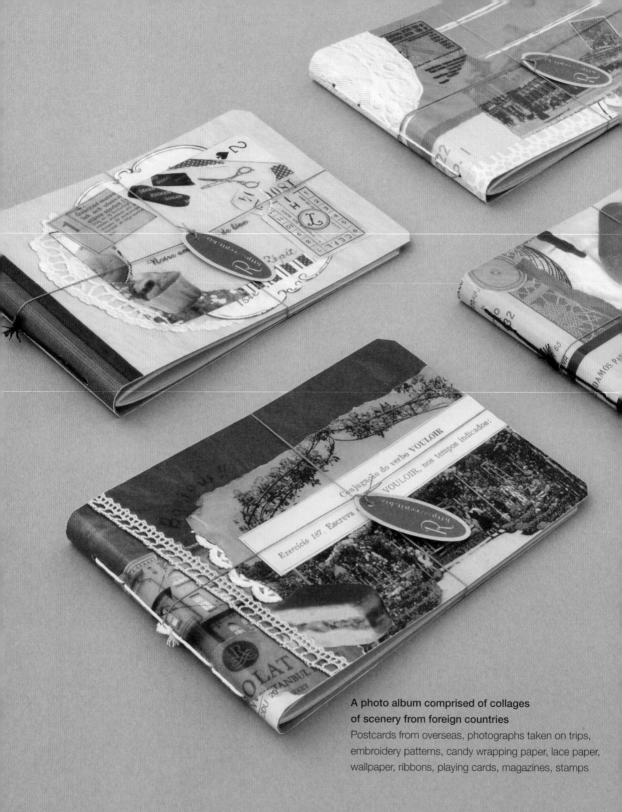

**A photo album comprised of collages
of scenery from foreign countries**
Postcards from overseas, photographs taken on trips,
embroidery patterns, candy wrapping paper, lace paper,
wallpaper, ribbons, playing cards, magazines, stamps

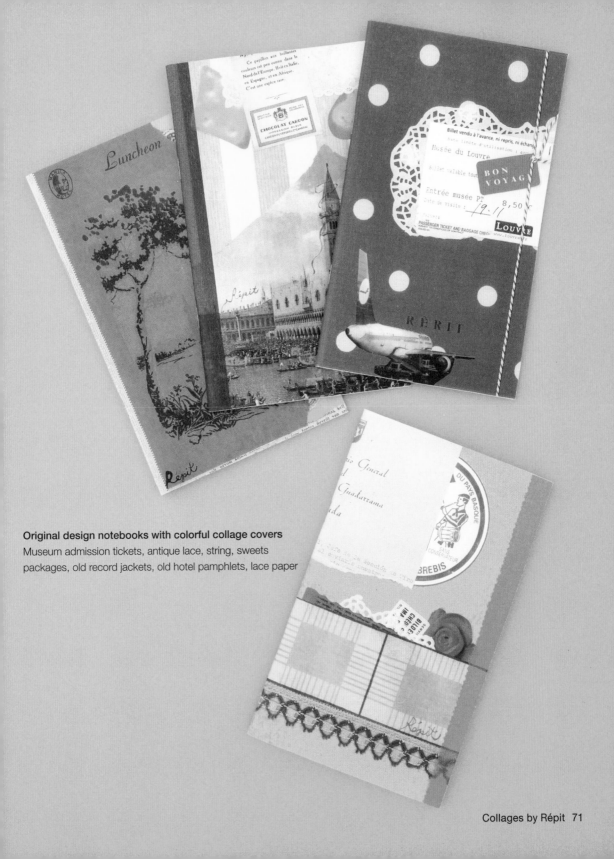

Original design notebooks with colorful collage covers
Museum admission tickets, antique lace, string, sweets
packages, old record jackets, old hotel pamphlets, lace paper

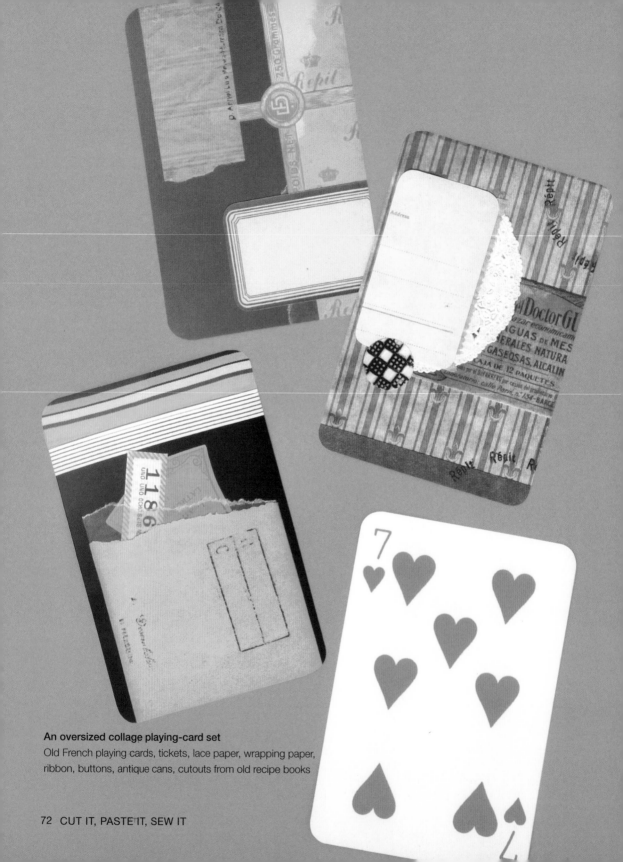

An oversized collage playing-card set

Old French playing cards, tickets, lace paper, wrapping paper, ribbon, buttons, antique cans, cutouts from old recipe books

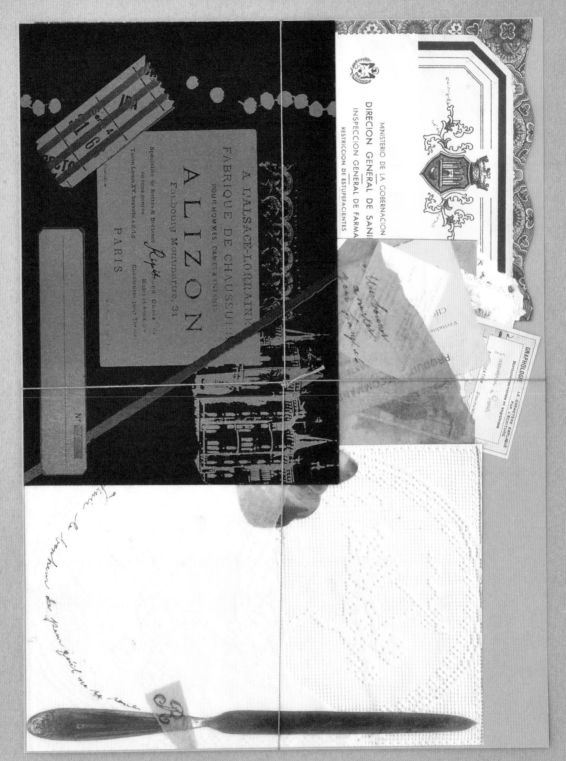

A letter set decorated with playfully overlapping paper

Antique lace, a paper knife, cards found at a flea market, hotel labels, photographs, oil paper, masking tape

Artist Interview: Répit

》 What materials do you use most often? And can you give us some pointers on material selection?

A lot of the time we use old paper and labels, ribbons, stamps, and other things we find at flea markets when we travel, but we also use some of the photographs we take ourselves. If we decide that we want to include three-dimensional items or foods such as sweets, we can take photographs of them and render them in planar form by making photocopies; it's a lot of fun trying to come up with ways to use everything possible as material for our collages. Also, when we combine materials, we try to pay attention to color schemes.

》 What's your secret to making a good collage?

After we decide on a fundamental image and determine the main components of the collage, we look for combinations of materials that complement each other. For finishing touches, and to subtract from the cacophony (so as to ensure that our collage is not too jumbled) we use paint, or lace for a little bit of camouflag and to provide balance. Since we transform our collages into stationery, we try to create collages that are not just colorful and glamorous; by leaving a lot of white space or hand-rendering letters, we achieve a relaxed expression that blends easily with our everyday lives.

》 Répit (Keiko Adachi and Mika Aoshima)

Based in Osaka, Japan, the Répit duo began making original collages in 2002. The unit transforms the collages made from the diverse materials it collects in its travels to countries such as Spain, Portugal, and France into original works of stationery. From design to production, every piece is still made almost entirely by hand, exuding a warmth and a uniqueness possible only with hand-crafted products. Répit's work is currently available via Web shops, events, and through a variety of shops in Kansai and throughout Japan.

》 Contact

Email: repit@leto.eonet.ne.jp
URL: http://repit.biz

8 Collages by Yuki Nakamura

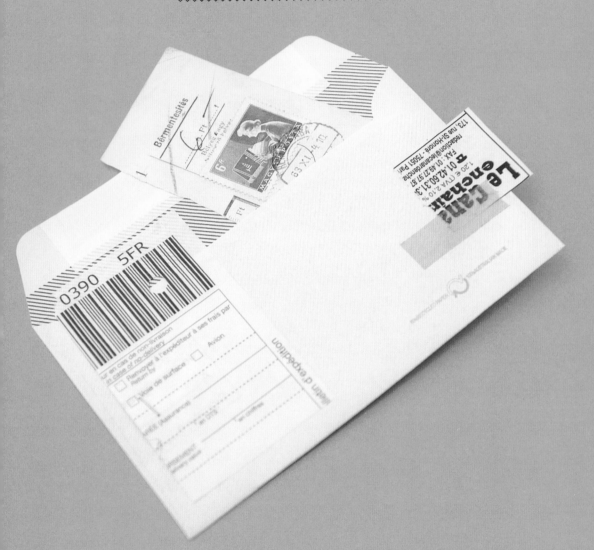

Collages with beautifully rendered margins …
This is where the meticulousness of Yuki Nakamura expresses itself.

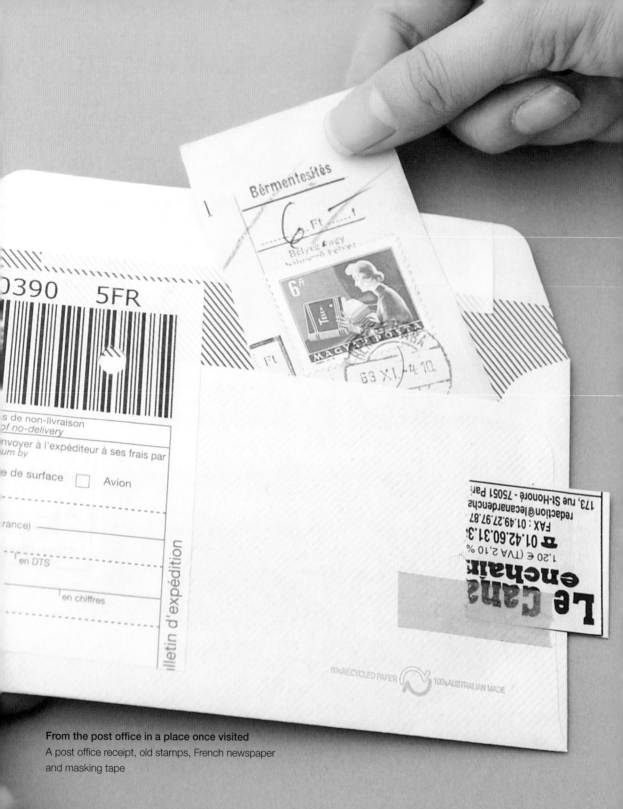

From the post office in a place once visited
A post office receipt, old stamps, French newspaper
and masking tape

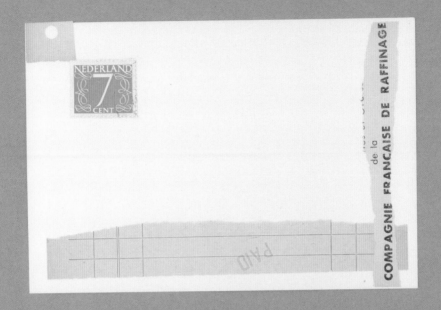

Collage cards where stamps play the leading role (numbers edition)
Old stamps, receipts, French newspaper

Collage cards where stamps play the leading role (airplane edition)
Old stamps, food product packaging, embossed masking tape for painting

Departures rendered in collage

Clips, an airplane pepper packet, double-sided tape,
old receipts from France, baggage tags from United
States, French office stamps

Collage cards made with unique paper material
A file, the paper wrapping from Russian toilet paper,
French newspaper, a paper bag

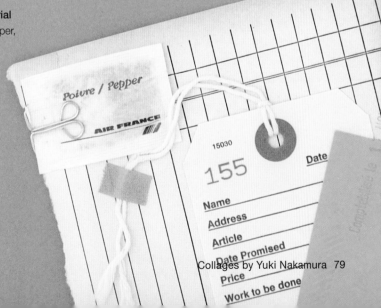

Would you care for some coffee?
Receipt paper from Europe, craft paper, French information magazine, an airline sugar packet

A collage for showing and keeping important things
A plastic bag, a baggage tag, old stamps, a colored paper sketchbook, French newspaper

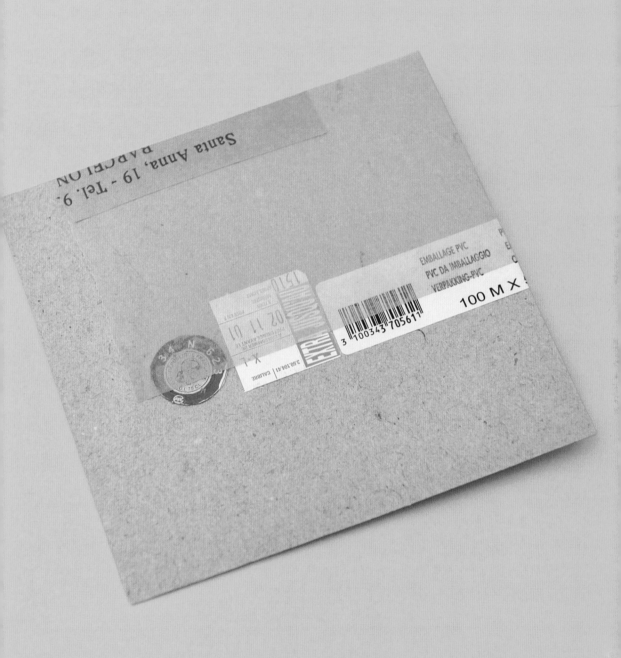

A collage card with a Marchais feel
Stickers from food products, price tag bar codes, thin
paper from a bread shop, craft paper

Artist Interview: Yuki Nakamura

》 What materials do you use most often? And can you give us some pointers on material selection?

Whenever I travel (mostly to Paris) I bring back almost everything, from stamps and tickets, the sugar packets you get in cafés, to food product packages and the kind of bags you find in marketplaces or at supermarkets, and just about any other free item that is familiar to us in our everyday lives. At flea markets, venders will wrap breakables in faded newspapers, but for me, even this faded newspaper is lovingly stored away. I buy old stamps by the bag at flea markets, and sometimes the things that some consider garbage and throw away can, for me, turn out to be quite precious.

》 What's your secret to making a good collage?

As with my drawings, I pay most attention to the rendering of empty space. I avoid cramming too many types of paper in a single collage, and with colors, I choose one that will play a central role and gradually add to the collage, all the while trying to maintain balance. The process is made much smoother if you select just one type of paper that you want to feature the most in the collage, as opposed to trying to fit everything in. The concept is to "share my travels." Whenever I send a card to a friend, for example, I try to impart a little of the fragrances and memories I experienced.

》 Yuki Nakamura

Illustrator and proprietor of Trico+, Yuki Nakamura is active mainly as an illustrator for advertisements, magazines and books, but also applies her talents to product planning and variety goods coordination for shops. From her studio during special events she holds a few times a year, she operates Trico+, a combination French variety goods store, mini-café and gallery. Major publications include *The History of the Haberdashery*, *A Tour of Kyoto Stationery*, *Diary of Parisian Haberdasheries* and numerous other works.

》 Contact

Email: yuki-be@ka2.so-net.ne.jp
URL: http://tricoplus.petit.cc

9 Collages by les deux

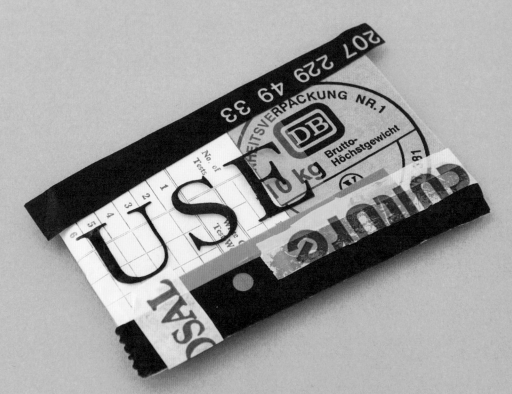

With "travel and things" as their conceptual basis, les deux's collages feature rich textures. Cool colors and the warmth of handcrafted products engender exquisite balance.

A cardboard collage card
A plastic shopping bag, cardboard, colored paper

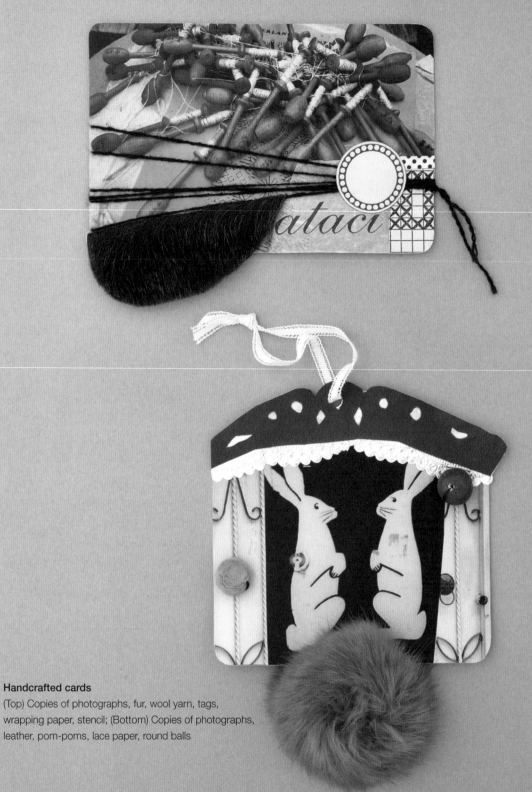

Handcrafted cards

(Top) Copies of photographs, fur, wool yarn, tags,
wrapping paper, stencil; (Bottom) Copies of photographs,
leather, pom-poms, lace paper, round balls

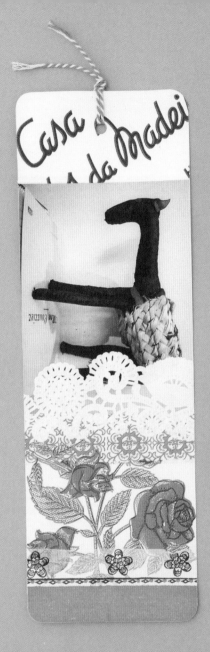

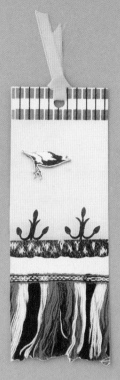

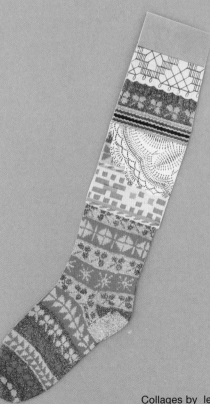

Tag cards
Copies of photographs, wrapping paper, lace paper, paper napkins, ribbons

Bookmarks
Copies of photographs, wrapping paper

Latvian sock bookmark
Copies of design and lace patterns

Needlework books

A needle set, old fabric, ribbons, buttons, string, old magazines

COLOR AND STITCH KEY
FOR POPPY AND
CORNFLOWER PILLOW

1 Light Orange
2 Medium Orange
3 Bright Orange
4 Red
5 Pale Blue
6 Blue Violet
7 Medium Blue
8 Green Blue
9 Dark Blue
10 Dark Purple
11 Pale Green
12 Green
13 Dark Green
A—Work parallel rows
of outline stitch

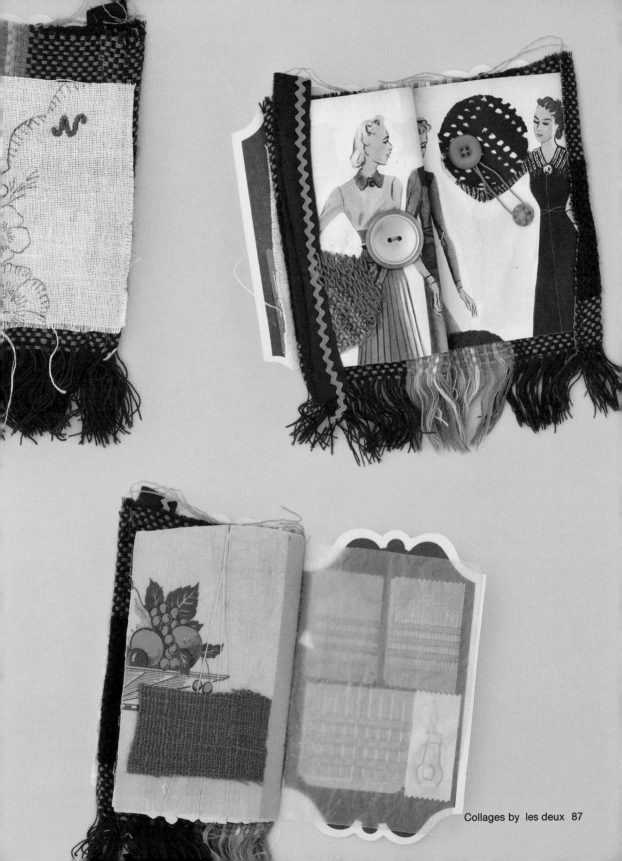

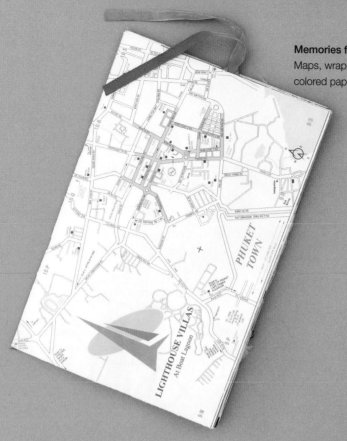

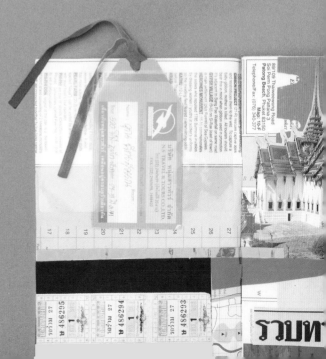

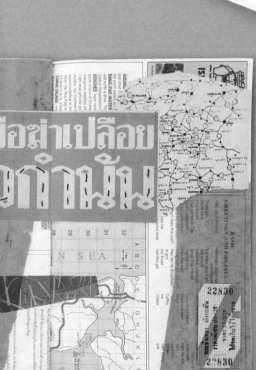

Memories from my travels

Maps, wrapping paper, newspaper, tags, tickets, colored paper, ribbons, feathers

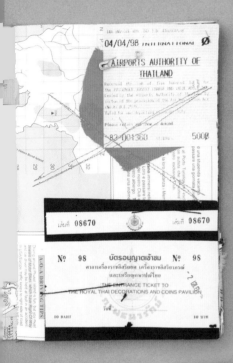

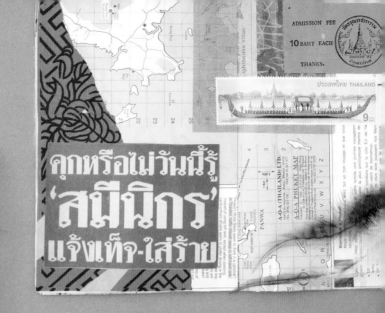

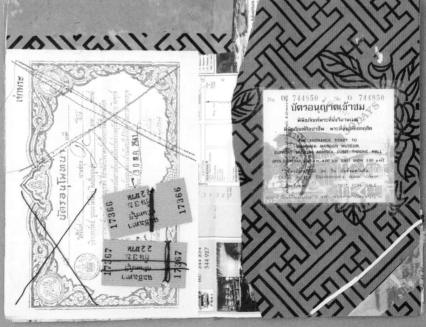

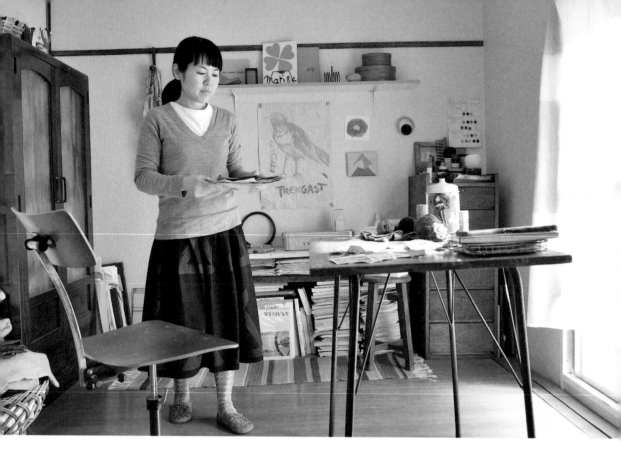

Artist Spotlight: les deux (Miyuki Matsuo)

》 I understand that you work mostly as an illustrator, so when did you start making collages?

My very first encounter with collages was in university when I was traveling overseas. I was making an album out of the photographs I had taken and I started pasting paper on it. That's when it all started. I wasn't doing it to show anyone, per se. It's just that I found no enjoyment in simply sandwiching my photographs between sheets of plastic. I just happened to have a notebook made from recycled paper, and since it was pretty durable, I started pasting to it the tickets and other items I had gotten during my trip and adding some lettering here and there… This is how it all began.

》 Are there any similarities between illustrating and making collages?

For me, illustrating is much easier. I sometimes find working solely with collages really difficult. I feel that the collage is the sum of its materials, and sometimes I think they can be really difficult to work with if you don't have the materials you have in mind. I often don't want to use a particular type of material unless I really like it, and I get tired of using the same things all the time, so I am always out looking for anything that could be used as collage material. Finding new materials inspires me to make a new collage.

》 What are some of the materials you use the most in your collages?

Since my collages are comprised of things I collect at places I've visited, I probably use the items I collect when traveling the most. Also, rather than using brand new things, I prefer to use dead stock paper, or magazines and such that I pick up at antique book stores. When I am overseas, I buy things at flea markets and visit antique book stores. Since I also frequently use handcrafted material, I make a point of looking for them when I go to flea markets. My main purpose in

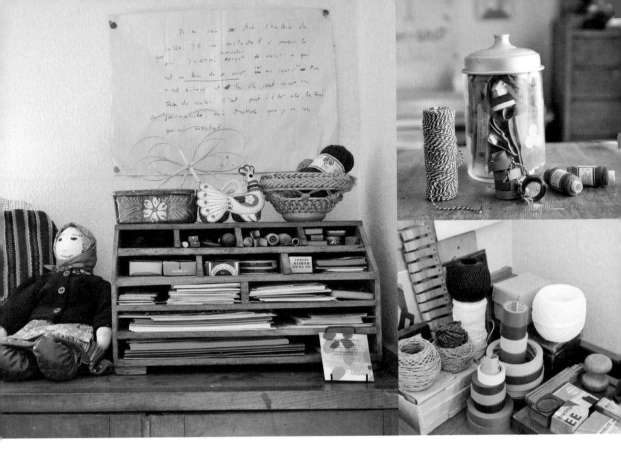

travel, though, is not to look for material; I travel for the enjoyment of it but make time to look for material at the same time.

❱❱ Do you travel overseas regularly?

No, not really. Maybe three times a year? That's why I find my encounters overseas so precious. Whenever I find something good, I try to buy as much of it as I can, particularly since I don't always find things I like. When I go shopping, I always think first about whether an item will be easy to use, or choose things that will generally be amenable to handcrafting. In the case of dead stock, for example, I stay away from character items because they are hard to use. I look for items that can be easily used as accents, rather than things that have a presence that is in and of itself overpowering. When I travel overseas, it is most often to Europe, particularly France and northern Europe. The cityscapes, the different colors I encounter in each nation—these are the things that inspire me most.

❱❱ You often use wool yarn and pom-poms in your work, don't you?

Yes, I do. Since I like handicrafts, I enjoy working with paper and fabric. But paper by itself is too planer, so I use yarn or pom-poms when I want a three-dimensional effect or to integrate different material."

❱❱ Have you always used masking tape?

I liked working with colored packing tape, even before they started to make all of the colors we have today. Nowadays, there is a wide variety of colors of masking tape to choose from; they lend a sense of opacity that is easy to use.

❱❱ What is uniquely you that you try to incorporate into your collages?

I guess I would have to say the way I use colors. I tend to use a lot of cool colors, purples and dark browns, and maybe pinks for a little accent. I think this use of color is what makes me unique.

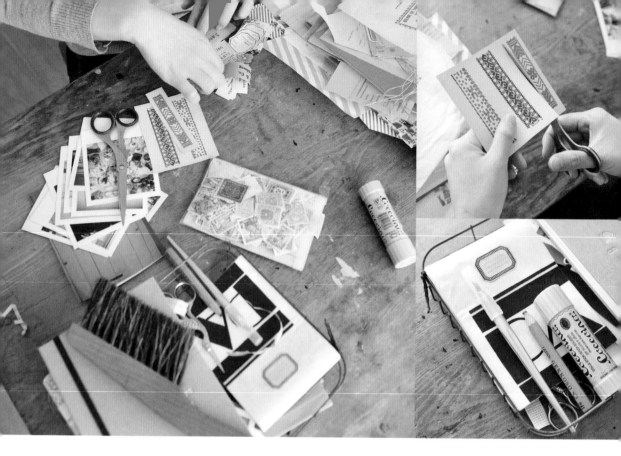

》 And, of course, there is the work you do as the "les deux" unit…

Travel books and haberdashery items we do as les deux; illustration work I do alone. The other half of les deux, Takimura, runs a variety goods store. We've known each other since we were both working at a second-hand clothing store in Nagoya, Japan, years ago. Since moving to Tokyo it's become difficult to find the time to work together, but when I was in Nagoya, I spent a lot of my time at her shop, where we made a variety of things together.

》 When you were working closely together, did you both work at the same time on the same piece?

Many of our pieces we worked on together, but we sometimes work separately, too. When I work, I always decide on a layout before pasting my materials together, but Takimura works with an almost unerring momentum. The collage, from material selection to the process of pasting all the pieces together, may be one of the easiest ways to express one's personality.

》 That is what makes collages so thrilling, isn't it?

Yes, it is. And, then there is the unexpected movement you get depending on the combinations you choose. With illustration, you develop a sense for what the end result will be, but with a collage, you don't know what you will get until it's finished. The astonishing results you can achieve, even though the layouts and colors you select seem to fit perfectly at the time, is what makes collages exciting.

The elements that comprise the collages of Miyuki Matsuo

Retro paper items
She uses a variety of paper items of diverse hues and textures. Shel likes to use a collection of older rather than new paper with a little bit of a retro feel.

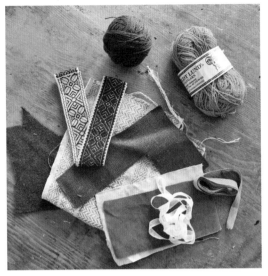

Handicraft materials
She uses wool yarn and bits of fabric and tirolean tapes of soft, gentle colors. Warm textures are the fundamental elements that make Miyuki Matsuo's collages unique.

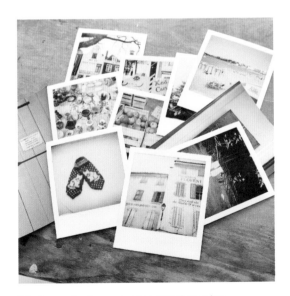

Photographs from places visited on trips
The pale hues of Polaroids make beautiful photographs. The pictures capture the buildings and scenery Miyuki Matsuo has encountered in her travels.

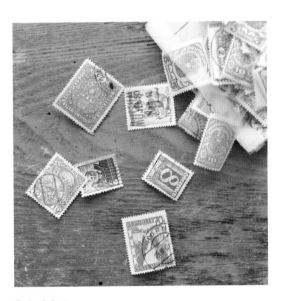

Colorful stamps
She uses stamps purchased at flea markets overseas. Sold by the bag, these international stamps feature charming designs and are extremely colorful.

Artist Interview: les deux

❯❯ What materials do you use most often? And can you give us some pointers on material selection?

I use a lot of wrapping paper and dead stock paper bags, tags, old magazines and needlework patterns from overseas. I also use pretty colored tape, textured fabrics and knits, and so on to provide accents. To make sure that the accents are not too overpowering, I make sure to use items that harmonize well with each other.

❯❯ What's your secret to making a good collage?

I maintain a tightly focused feel by bringing together tones that harmonize, and avoid a nebulous feel—I always add accent to parts of the collage. Since travel is frequently the theme of my collages, I try to bring out the colors and ambience that represent the colors of the countries that I feature in my collages of international items

❯❯ les deux (Miyuki Matsuo and Mihoko Takimura)

The two-person unit, comprised of illustrator Miyuki Matsuo and haberdashery owner Mihoko Takimura, was formed in 2002. Its design concept was "travel and things." Inspired by the stimuli received during its travels, the Matsuo and Takimura duo creates haberdashery goods, handmade books, and more. Their publications include *Collage of Our Travels—The Haberdashery and Lifestyle of the Three Baltic Nations* and *European Markets*.

❯❯ Contact

URL: http://lesdeux.exblog.jp

10 Collages by Tomoo Nishidate

Lost Pieces in London
A collage of the rubbish collected during my travels.
Price stickers, manufacturer seals

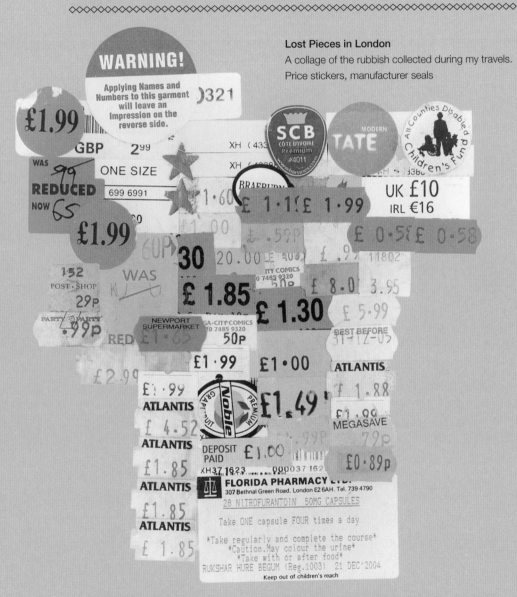

In the work of Tomoo Nishidate, naturally accumulated soil, distortion developed over time, and faded colors are transformed into the very allure of the material that comprise his collages.

Lost Pieces in London II

A collage of the rubbish collected during my travels.

Cardboard, matches, string

LOKNING LANE

@
MERA
25 FRITH STREET SOHO
el último sábado de cada mes
£5 en la puerta libra antes de 10pm
(...ha.co.uk) mark wimmers (afrocubansounds.com)
...m + guests
en la lista de invitados, enviar un email a:
...@querico.co.uk www.querico.co.uk

NOS

For additional Information call:
0845 1610001
(3,4 pence/min.)

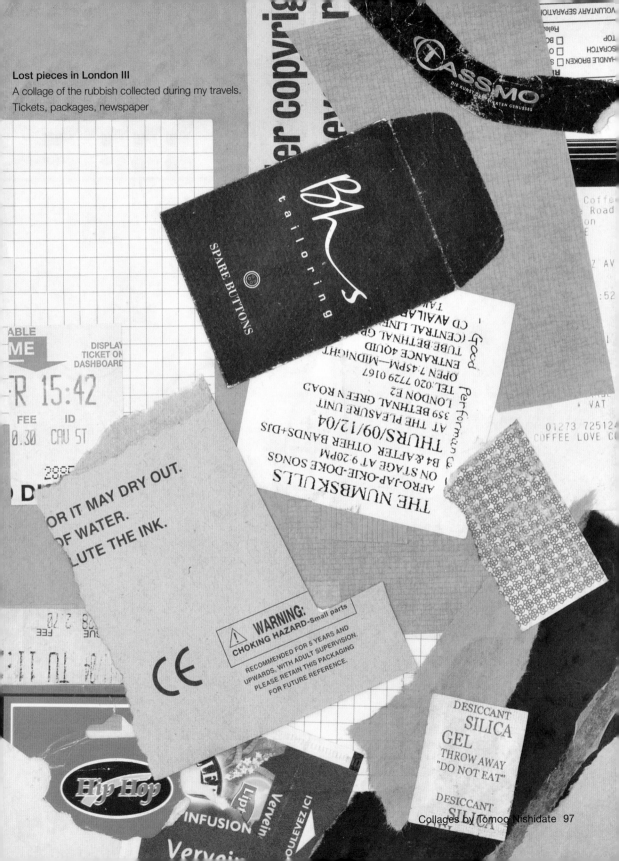

Lost pieces in London III
A collage of the rubbish collected during my travels.
Tickets, packages, newspaper

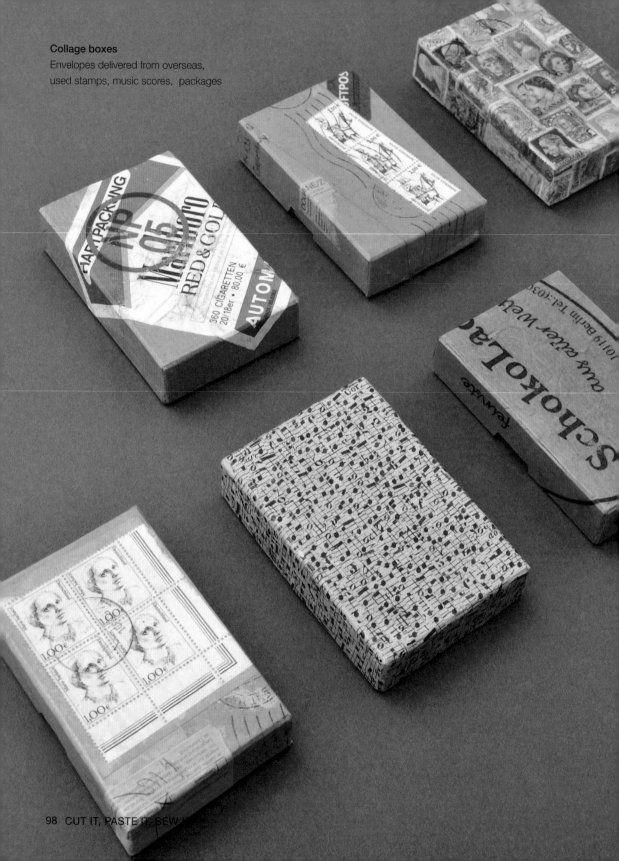

Collage boxes

Envelopes delivered from overseas,
used stamps, music scores, packages

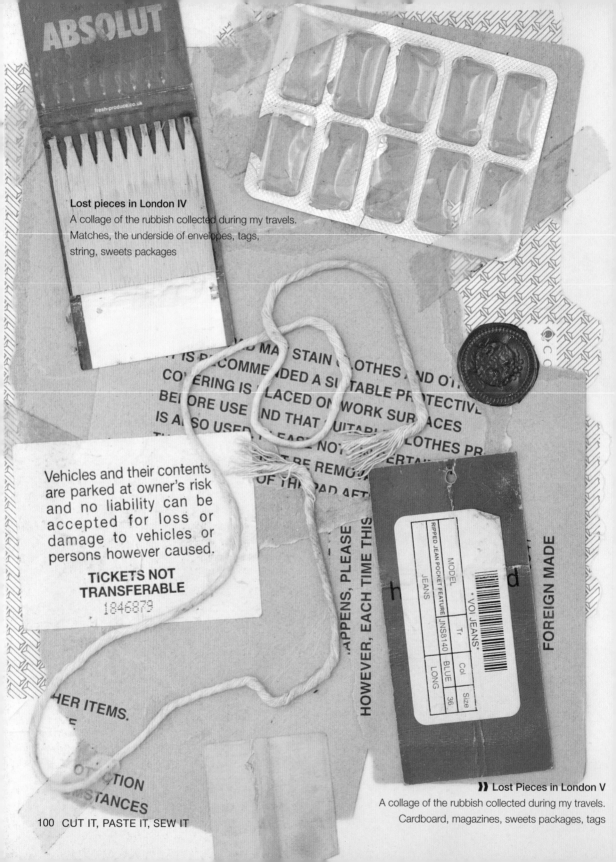

ABSOLUT

fresh-produce.co.uk

Lost pieces in London IV
A collage of the rubbish collected during my travels.
Matches, the underside of envelopes, tags,
string, sweets packages

IT IS RECOMMENDED A SUITABLE PROTECTIVE
COVERING IS PLACED ON WORK SURFACES
BEFORE USE AND THAT SUITABLE
IS ALSO USED. PLEASE NOT
IT MAY STAIN CLOTHES AND OT
CLOTHES PR
BE REMOV
OF THE PAD AFT

Vehicles and their contents
are parked at owner's risk
and no liability can be
accepted for loss or
damage to vehicles or
persons however caused.

**TICKETS NOT
TRANSFERABLE**
1846879

APPENS, PLEASE

HOWEVER, EACH TIME THIS

HER ITEMS.

TION
STANCES

VOI JEANS

RIPPED JEAN POCKET FEATURE
JEANS

FOREIGN MADE

MODEL	Tr	Col	Size
JNS8140		BLUE	36
	LONG		

❯❯ Lost Pieces in London V
A collage of the rubbish collected during my travels.
Cardboard, magazines, sweets packages, tags

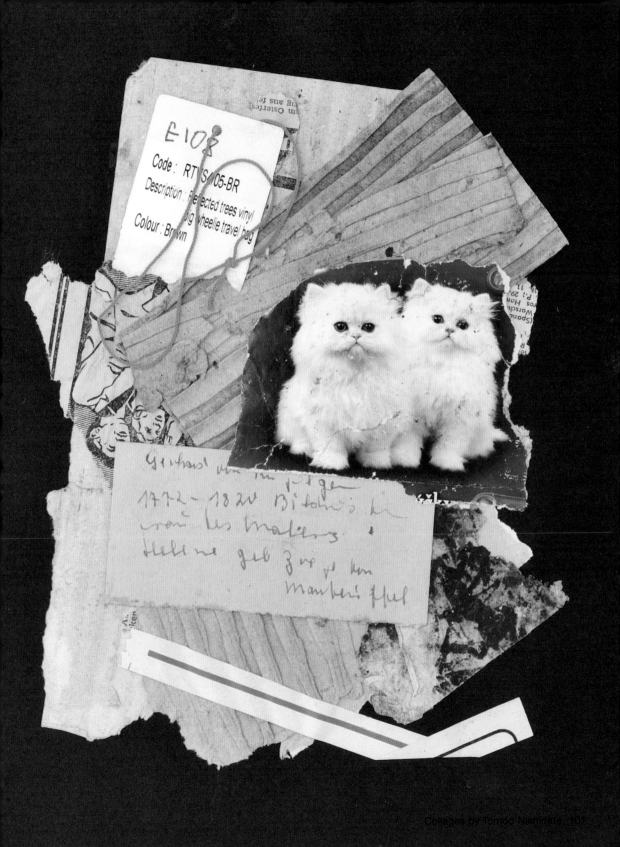

Artist Interview: Tomoo Nishidate

》 What materials do you use most often? And can you give us some pointers on material selection?

I use everything I can find, from scraps of paper, cardboard, plastic, and so on, that I find on the street to antique books. I particularly like using items whose intrinsic colors and forms are transformed unexpectedly, appealingly over time as a result of their environmental conditions, be they natural or man-made. As far as material is concerned, I am particularly concerned with colors, form, and textures. I don't really pay much attention to their original meanings; I choose everything from a planar sense of value.

》 What's your secret to making a good collage?

I try to make the colors and shapes and the other aspects I find most attractive about the materials I use stand out.

》 Tomoo Nishidate

Born in 1978, Tomoo Nishidate went to work for a music production company after graduating from university. After leaving the company in 2004, he began making collages in diarylike sketchbooks using the trash he encountered during his travels in England. It was at this time that he began working in earnest as an artist and designer. In addition to numerous exhibitions, Nishidate's work spans a wide range of fields, from magazines, CD's, advertisements and three-dimensional works of art to exhibition direction and other forms of spatial presentation.

》 Contact

Email: tmon423@mbp.nifty.com
URL: www.tomoonishidate.com

11 Collages by Kayo Yamamoto

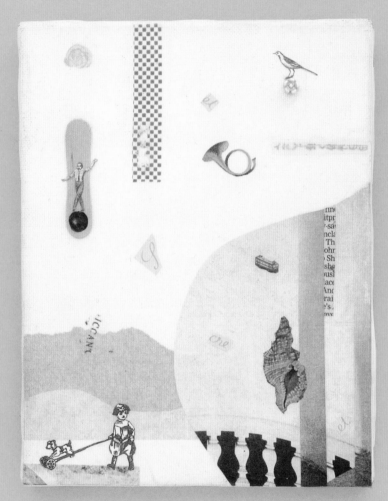

Kayo Yamamoto's collages are both charming and uniquely powerful.

Dream
A wooden spoon, thin paper, tracing paper, beads, packaging, paper items, English language newspaper, cutouts from toy catalogs, etc.

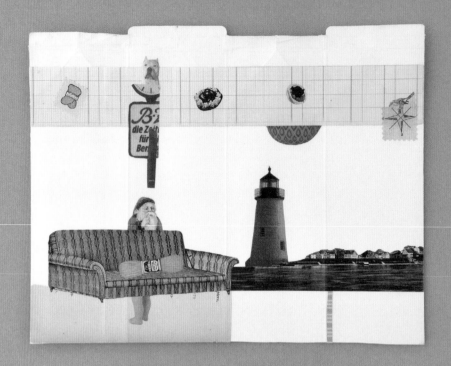

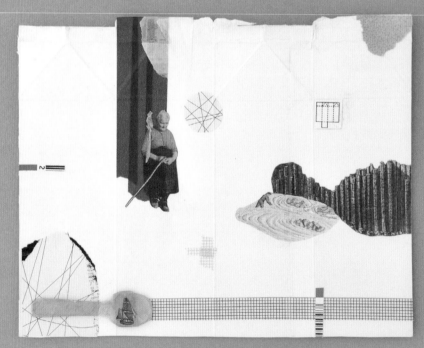

Collage déjà vu: ocean voyage

Milk carton, an old notebook, cutouts from international magazines, wrapping paper, cutouts from magazines, etc.

Collage déjà vu: afternoon nap

Milk carton, masking tape, cutouts from western magazines, copies of old natural history illustrations, a plastic spoon, etc.

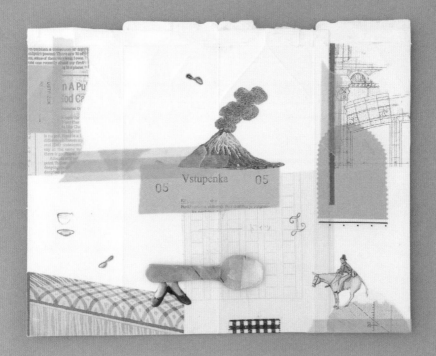

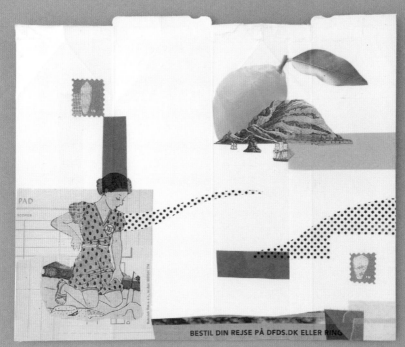

Collage déjà vu: world travels
Milk carton, masking tape, copies of passes to western castles, map paper, manuscript paper, tickets, a plastic spoon, etc.

Collage déjà vu: seaside
Milk carton, cutouts from old newspapers, cutouts from magazines, international newspapers, copies of shell illustrations, etc.

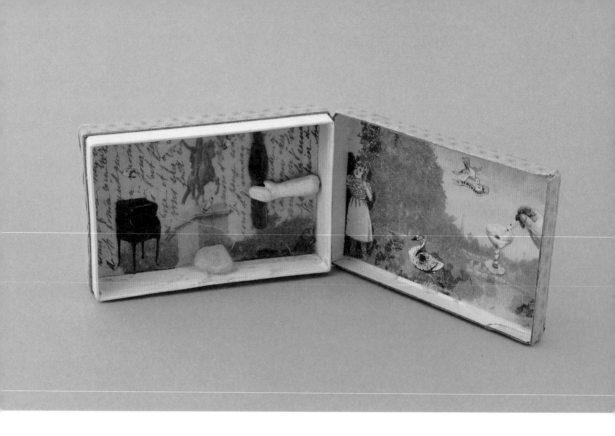

A letter

Tip of a pen, old postcards, a doll's arm, a stone, patron paper, etc.

Constellation collage cards

Cutouts from old catalogs, wrapping paper, masking tape, colored paper, foreign newspapers, dead stock notebooks, lace paper, stamps, etc.

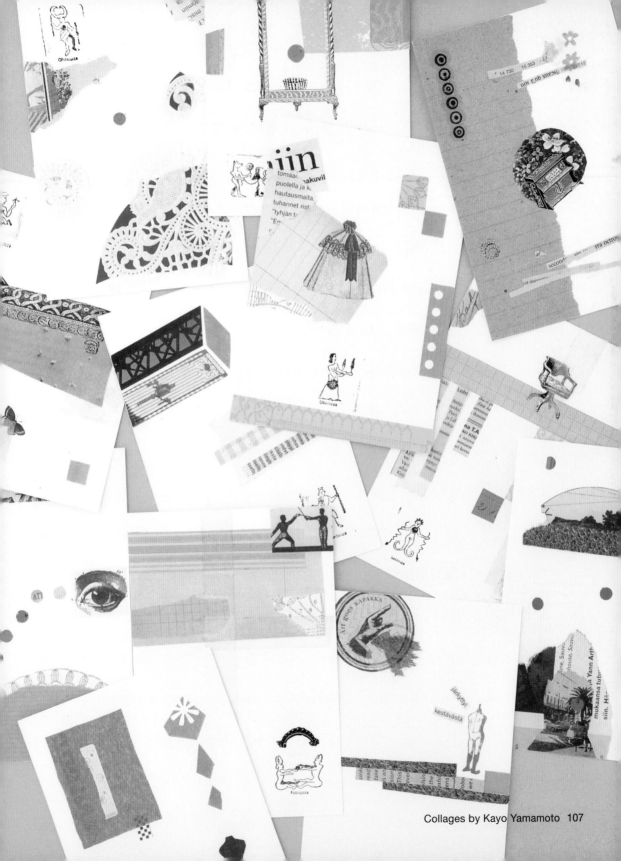

西

Stillingens indhold gør det nødvendigt, a
• Er elektriker eller har erfaring med arbe
• Har erfaring med montage af distributic
 lavspændingsnet i jord
• Har god forståelse af tegninger m.v.

Som

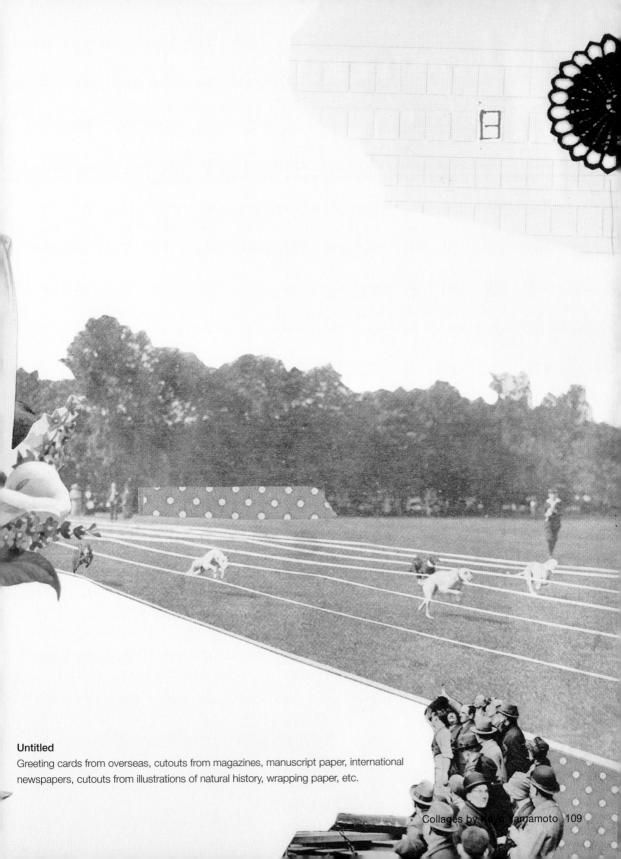

Untitled
Greeting cards from overseas, cutouts from magazines, manuscript paper, international newspapers, cutouts from illustrations of natural history, wrapping paper, etc.

Artist Interview: Kayo Yamamoto

❯❯ What materials do you use most often? And can you give us some pointers on material selection?

A variety of items such as international newspapers, cutouts from old newspapers, antique books, wrapping paper, used stamps, dead stock notebooks, Japanese paper, masking tape, paper copies of fabric, lace paper, grunge paper, and so on. I also use flower petals, fallen leaves and other natural items. Generally speaking, I believe that my materials are embedded in my daily life, especially the things we throw away, the things that have already been discarded. They can yield some precious items. I've come to look at everything as a possible collage, so I don't easily discard of anything anymore.

❯❯ What's your secret to making a good collage?

In my case, I avoid detailed categorization of my materials. I collect everything in a number of bags that I can easily keep track of. I start by picking a bag and using the materials inside in a free-spirited manner. Regardless of whether or not I am working from a clear concept, the collage begins from the moment I choose my materials. Most of the time I choose one visual aspect that will become the main focus of the piece (I am often reflected in the things I choose). From there I consider color coordination and balance, and I try to find the perfect positioning without thinking too hard about it. It's like allowing the fortuitous encounters of different materials to be inevitably transformed by my own sense of aesthetics. I think that observers can really tell when I have truly enjoyed making a collage. The end result is a set of materials coming together to create and act out sublime encounters in a singular universe—it is because of the enjoyment this brings that I continue to create collages.

❯❯ LUSiKKA design Kayo Yamamoto

In the more than ten years since her first collage creation, freelance graphic designer Kayo Yamamoto's work has been displayed in numerous exhibits, and she is gradually expanding more and more into artwork outside of the world of design. Her work includes the bookbinding for *The Joy of Little Press, Continued*, flyers, panels, paper-crafted variety goods, and much more. Yamamoto works part-time as an art instructor in public schools and holds collage workshops. We hope to see an even more expansive development in her collages in the future.

❯❯ Contact

Email: kayo_colle@r6.dion.ne.jp
URL: www.k2.dion.ne.jp/~kayo_co

Resources

UNITED STATES

A.C. Moore craft stores
www.acmoore.com

Daniel Smith
www.danielsmith.com

Dharma Trading Co.
www.dharmatrading.com

Dick Blick Art Materials
www.dickblick.com

The Fine Art Store
www.fineartstore.com

Michaels
www.michaels.com

Paper Source
www.paper-source.com

Pearl Paint Company
www.pearlpaint.com

R&F Handmade Paints
www.rfpaints.com

Utrecht Art
www.utrechtart.com

EUROPE AND UNITED KINGDOM

Creative Crafts
www.creativecrafts.co.uk

AUSTRALIA

Eckersley's Arts, Crafts, and Imagination
www.eckersleys.com.au